NEW YORK IN THE SIXTIES

NEW YORK IN THE SIXTIES

EDITED BY
GEORGE PERRY

PAVILION

Picture Editor: Suzanne Hodgart
Art Director: Grant Scott

First published in Great Britain in 2001 by
PAVILION BOOKS LIMITED
London House, Great Eastern Wharf
Parkgate Road, London SW11 4NQ
www.pavilionbooks.co.uk

ISBN 1 86205 426 6

Colour reproduction by Bright Arts, Hong Kong
Printed and bound in Spain by Graficromo

10 9 8 7 6 5 4 3 2 1

This book can be ordered direct from the publisher. Please contact
the Marketing Department. But try your bookshop first.

Opposite: Broadway Salute

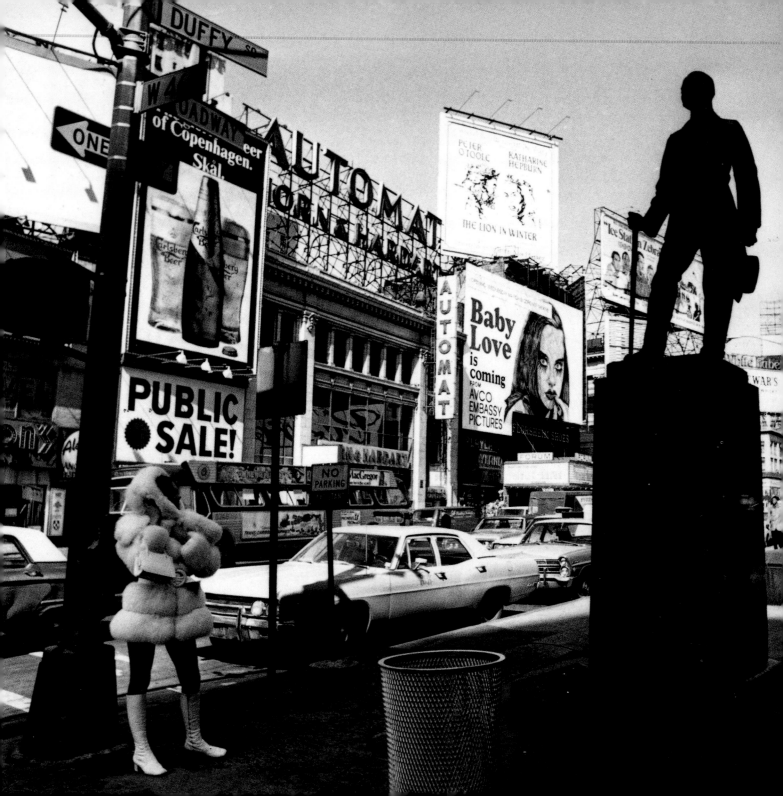

Some cities, mostly to be found in the Old World, never seem to change, remaining as if pickled in time. New York is at the opposite end of that spectrum. So volatile is the place that every traveller finds that it has more or less reinvented itself since the last visit. The smart restaurants, the personalities, the talking points, the shows to see, the buildings to admire, the places to stay, are always mutating in the shifting sands that form the world's greatest metropolis. For native New Yorkers the changes may be perceived as more gradual, but nevertheless their effects are palpable. The restlessness of the city is a defining characteristic, and is one of its greatest attractions. If the city of New York has any constancy at all it is in the special stimulus that gives its atmosphere an adrenaline surge absent in other urban centres, as though the confluence, as the Hudson River sniffs the Atlantic Ocean, invokes a potent vortex that energizes those who live there.

New York City is, of course, rather more than the island of Manhattan. There are four other boroughs, three of which are also situated on islands, and in land area far eclipsing Manhattan, but usually overlooked in any consideration of what is meant by New York.

At the beginning of the 1960s John Wayne still blew smoke rings from a huge advertisement on Times Square, while nearby the Pepsi-Cola waterfall pumped thousands of gallons of water a minute in a spectacular display high above the street. The Astor Hotel, and the theatre bearing the same name, in which Frank Sinatra first assailed the public consciousness in 1943, still stood, as did the monumental Capitol movie palace, a few blocks north on Broadway. New Yorkers enjoyed a wide range of newspapers, more than any other city in the United States. During the 1960s the *World-Telegram*, the *Journal-American* and the much admired *New York Herald Tribune* all vanished as a consequence of changed economics and labour disputes. For a short time the three were yoked together in an unappealing hybrid called the *World Journal Tribune*, which swiftly closed.

Back in 1960 the Cunard liners *Queen Mary* and *Queen Elizabeth* still berthed at Pier 90 on the West Side, and thousands of commuters every day thronged the Romanesque splendour of Pennsylvania Station, with its waiting room modelled on the Baths of Caracalla.

Penn Station was a turning point. The great McKim, Mead and White building, confidently expressing the vitality of the railroad age when it was built in 1910, had become grimy and tired, its magnificent interiors cluttered with inappropriate retailers' stands. In 1960 a deal was struck to tear it down and build a relocated Madison Square Garden arena over a new subterranean Penn Station which would have all the charm of a bloated subway stop. By 1964 the jackhammers and wreckers' balls had done their worst.

The destruction of such a celebrated landmark managed to galvanize some New Yorkers into questioning the city's appetite for constant renewal, especially when

excellence was to be replaced by mediocrity. Action groups managed to block a similar fate for Grand Central Terminal, although the outcry was too late to prevent the construction of the monolithic Pan Am Building (now MetLife), at the time the largest office building in the world, and which destroyed the formerly satisfying vista along Park Avenue.

Among other significant architectural and engineering developments of the period were the construction of the giantesque twin towers of the World Trade Center in Lower Manhattan, begun in 1966; and the completion in 1964 of the elegant Verrazano-Narrows Bridge, then the longest suspension span in the world, connecting Brooklyn to Staten Island, which ended the latter's isolation from the rest of Greater New York.

The ebullience of the age led to the staging – under the leadership of Robert Moses, who probably more than any other public figure was responsible for the 1960s transformation of the look of New York – of an elaborate, drum-beating World's Fair, 25 years after the famous 1939 event, on the same marshy site at Flushing. Like its predecessor, it was successful enough to be reprised the following year, but architecturally lacked the earlier appeal, although there was an abundance of commercial sponsorship and concomitant deification of consumerism. Nearby Shea Stadium reverberated to the sound of The Beatles as they made their American debut, but it was in that same year of 1964 that serious race riots erupted in the densely populated streets of Harlem and the Bedford-Stuyvesant district of Brooklyn.

In 1965 a Republican was elected mayor, following the ten-year reign of the Democrat, Robert Wagner, among whose achievements had been stopping the demolition of Carnegie Hall. John Viet Lindsay was 43, the same age as President John F. Kennedy when he was assassinated in November 1963, and he had much of the latter's charisma. Kennedy had demonstrated that in the new media age the ability to command a television audience was a considerable asset to an aspiring office holder, and the handsome 6ft 3in (1.9m) Lindsay was particularly appealing to women voters.

Lindsay was horrified to inherit an administration that teetered on the edge of bankruptcy. He was by no means the first mayor of New York to feel that its social problems were so great and unique to the huge city that they almost warranted a secession from the state, if not the United States. There was a serious conflict on the issue of centralization, in which mundane local powers such as the placement of street lights or the collection of street garbage were under the control of remote city hall officials rather than the communities themselves. A tendency to concentrate powers in the name of municipal efficiency had eroded the responsibilities of the borough presidents and created tensions within the problem areas where health, housing, sanitation, education and other essential services were controlled by a remote central bureaucracy.

Recognizing that he was sitting on a powder keg that could explode at any time, Mayor Lindsay began to devolve some of the powers back to the borough presidents, and encouraged the formation of neighbourhood watchdog groups to monitor local problems and lobby for action. The issue that caused greatest concern was crime, which had been steadily escalating. Poverty

and poor housing were only a part of the problem. Another of the main causes was the alarming increase in drug usage. New York, as a main port of entry, acted as a magnet for dealers and addicts, and even in areas of midtown Manhattan, particularly around Times Square where smartly dressed theatregoers had to pick their way past pushers and junkies, the squalid ambiance sullied the image of a great city. By the end of the decade some midtown streets were no longer safe to walk on after dark.

The 1960s were a turbulent period for race relations. Among the most important figures of black protest was Malcolm X who, as a prominent member of the Black Muslim movement, was the minister of a Harlem mosque. His outspoken advocacy of black supremacy, violent retaliations against white America for its continued exploitation of his people, his demands for separatism, his repudiation of the civil rights movement, coupled with his hypnotic oratorical gifts, gave him a considerable following. He overreached himself with his unfortunate comments on the assassination of Kennedy, and at that point the Black Muslim leader Elijah Muhammad suspended him from the Nation of Islam. Malcolm X then set up his own splinter movement, but later modified his extreme views after a pilgrimage to Mecca. The schism between the two factions led to his assassination in Harlem by Black Muslims in February 1965.

Mayor Lindsay's greatest test came in 1968. The assassination of Martin Luther King Jnr in Memphis, Tennessee on 4 April caused racial unrest around the country, and Harlem was one of the principal focal points. Across the East River more trouble erupted in Bedford-Stuyvesant. The mayor went out and walked the dangerous streets, placating civic leaders and urging moderation on the over-stretched police. There were skirmishes, lootings, burnings, injuries and arrests, but a full-scale explosion was avoided.

Adjacent to Harlem is the campus, with many of its fine buildings designed by McKim, Mead and White, of Columbia University, a world-renowned, private Ivy League institution. In 1968 an insensitive university proposal to annex part of Morningside Park, the green strip that formed the demarcation line between the two communities – regarded by the black population as a valuable open space in a densely built-up district – in order to build a new gymnasium, invoked student demonstrations and sit-ins on a massive scale. There had already been many instances of the university authorities denying free speech to anti-Vietnam protestors, and segregationist policies were in use against black students, such as forcing them to carry passes, although illegal under civil rights legislation. Buildings were occupied and the business of the university was brought to a halt, but after several days of stand-off the police moved in. In the subsequent mayhem there were hundreds of injuries to students, academic staff and police, in one of the ugliest university confrontations of that eventful year. A further occupation occurred in 1969.

New York is a dominant force in the art world, and the 1960s were a period of intense creativity and upheaval. The Pop Art movement emerged with considerable vigour, its exponents including Roy Lichtenstein who worked on mammoth apparent enlargements of

comic strip frames, Robert Rauschenberg, with his silk-screen stencils, and Claes Oldenburg, whose soft sculptures of mundane objects attracted many imitators. Andy Warhol became a household figure in the early 1960s, having produced silk-screened images of Brillo cartons and Campbell soup cans, together with celebrity portraits repeated in patterns. Warhol was obsessed with film and created a genre of avant-garde cinema unique to himself. It is easy to dismiss his minimalist underground works such as *Empire*, in which the camera remains focused on the Empire State Building for eight hours, or *Sleep*, a similarly lengthy study of a man slumbering, as self-indulgent exercises, but later works such as *Heat*, *Trash* and *The Chelsea Girls* are powerful, innovative impressions of the Zeitgeist as perceived by Warhol. Surrounded by acolytes in his loft known as The Factory, renowned for his aphorisms and for holding court at the trendy Village rendezvous Max's Kansas City, as well as promoting the rock band The Velvet Underground, Warhol always attracted many column inches of publicity.

He, too, was an assassin's target. One of the women in The Factory, Valerie Solinas, who had produced a manifesto on behalf of SCUM (Society for Cutting Up Men) took a shot at him, wounding him seriously. The attempt on his life served to heighten his notoriety.

The performing arts flourished as never before. The ambitious Lincoln Center, a grouping of several auditoriums and institutions, took shape through the 1960s, commencing with the Philharmonic Hall (now the Avery Fisher Hall) in 1962, followed by the New York State Theater in 1964, and the relocated Metropolitan Opera House in 1966, together with several other auditoriums, the Juilliard School and the Library and Museum of the Performing Arts. Nearby in Central Park Joseph Papp, a leading off-Broadway theatre producer, inaugurated free performances of Shakespeare. In the inaugural 1967 season a show called *American Tribal Love-Rock Musical* was staged, then restructured by Tom O'Horgan, who had directed the Café La Mama company. In its new form, as *Hair*, it burst on to Broadway, causing an immediate sensation as the first hippie musical to hit the legitimate stage, with some members of the cast entirely shedding their clothes during the performance, albeit under tastefully subdued lighting.

At the close of the decade Tom O'Horgan was responsible for staging the world premiere of *Jesus Christ Superstar*, the work of two young Britons, Andrew Lloyd Webber and Tim Rice, signifying the beginning of a movement to end the one-way flow of stage musicals across the Atlantic, but the full effects were not to be realized until the decades that followed.

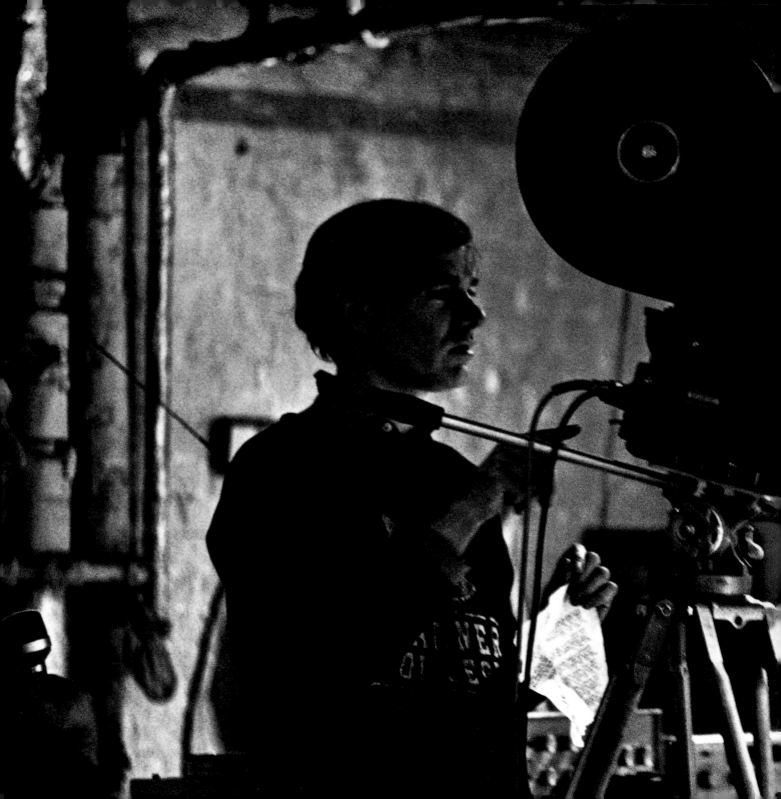

Artist Andy Warhol,
famous for more
than fifteen minutes

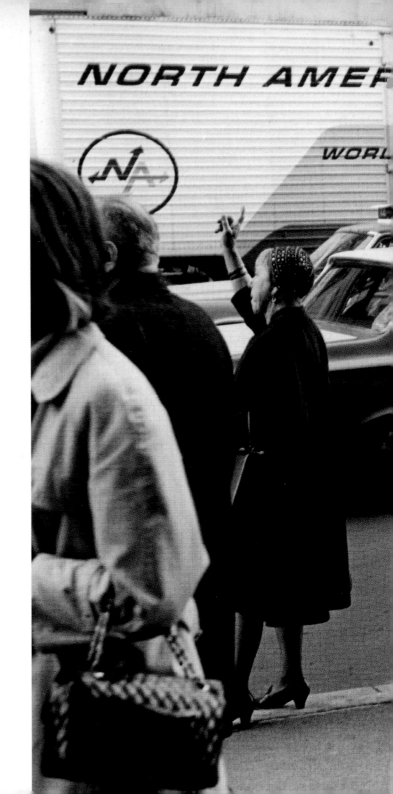

Like a rolling stone, songwriter and performer Bob Dylan cab hunts in New York

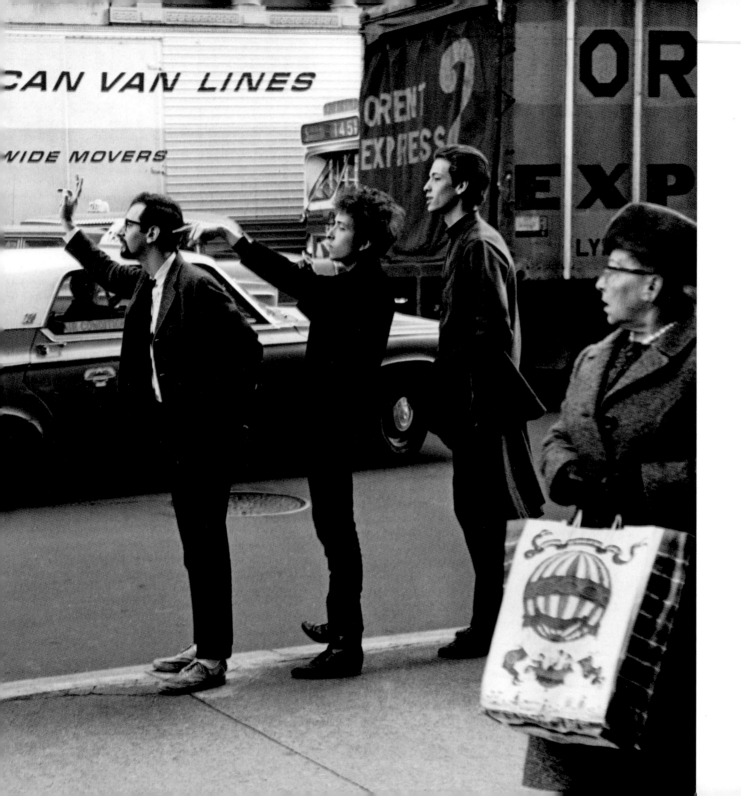

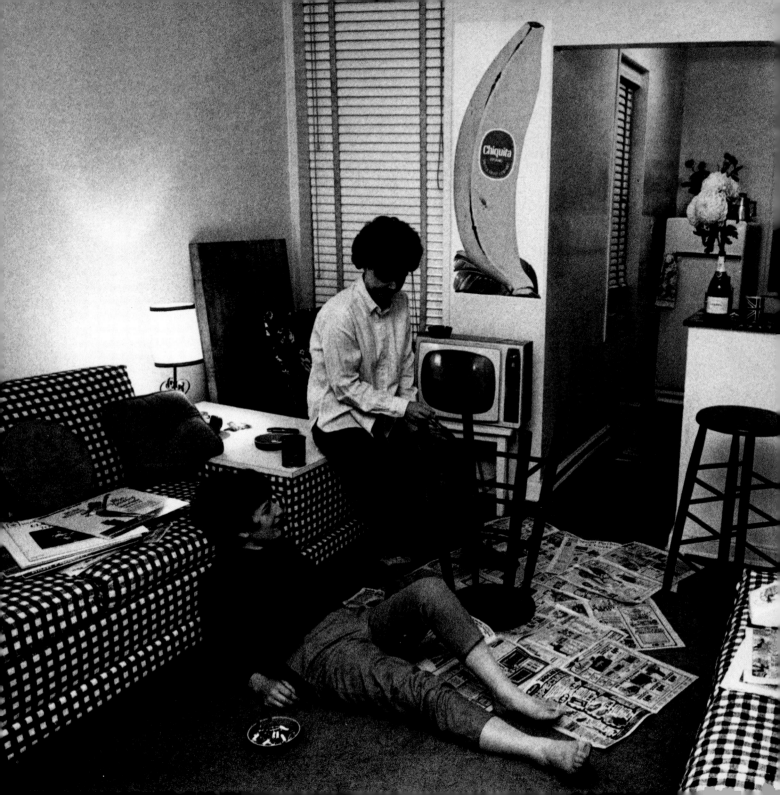

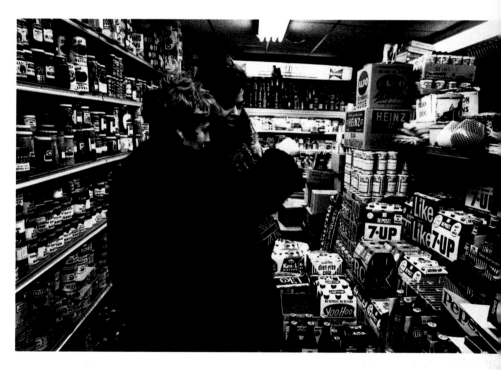

Above: Shopping for groceries

Left: Apartment-living in the city

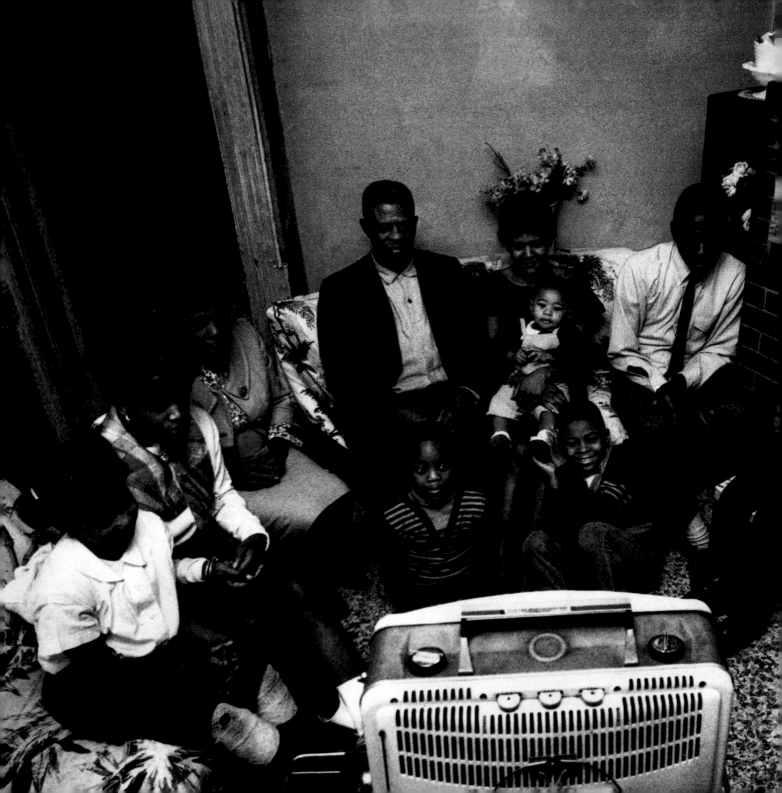

Left: Television – still a shared experience

Below: Black power

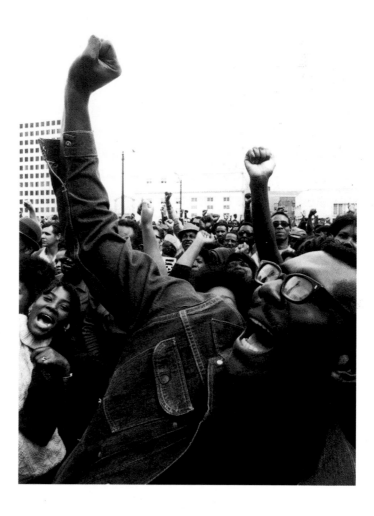

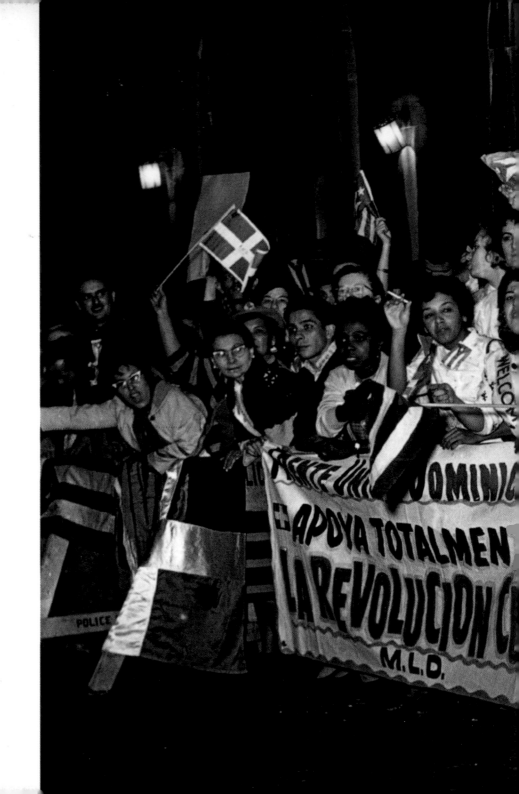

A greeting for Fidel Castro, president of Cuba

Overleaf: Fidel snubs the UN

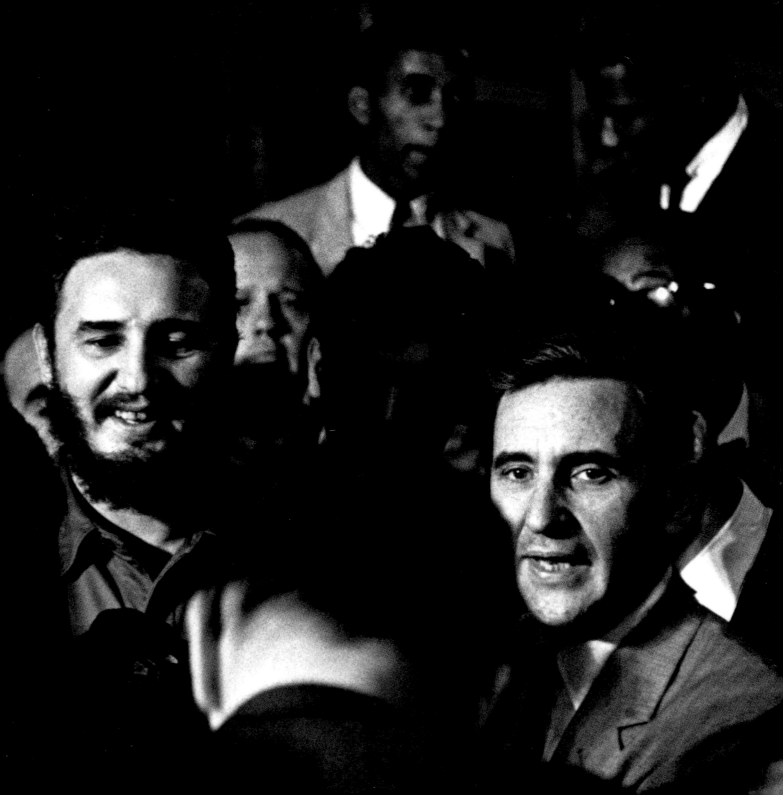

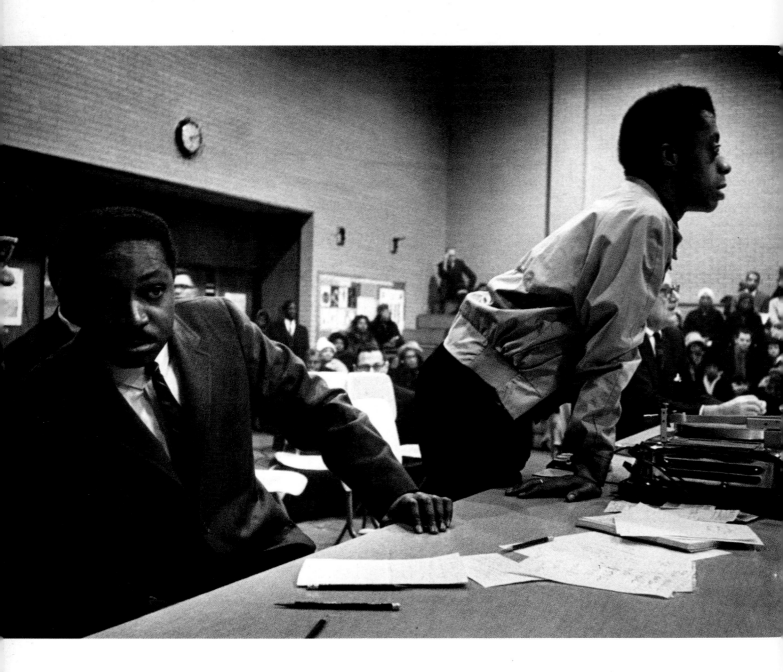

Left: Author James Baldwin bashes slumlords

Right: Poet Allen Ginsberg, speaks up for the Beats

Overleaf: Norman Mailer in Brooklyn (left) and Arthur Miller in Manhattan (right)

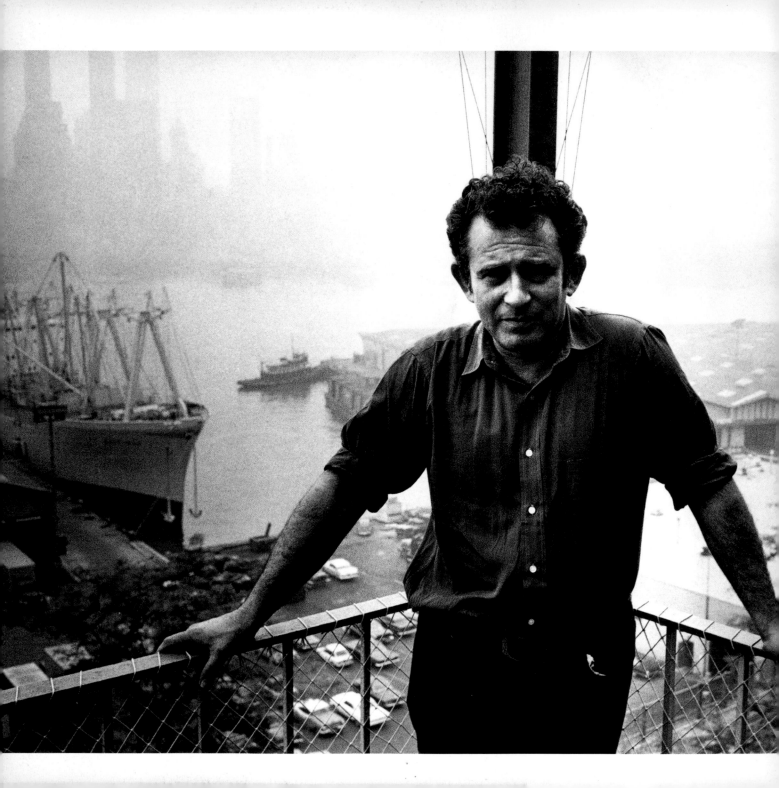

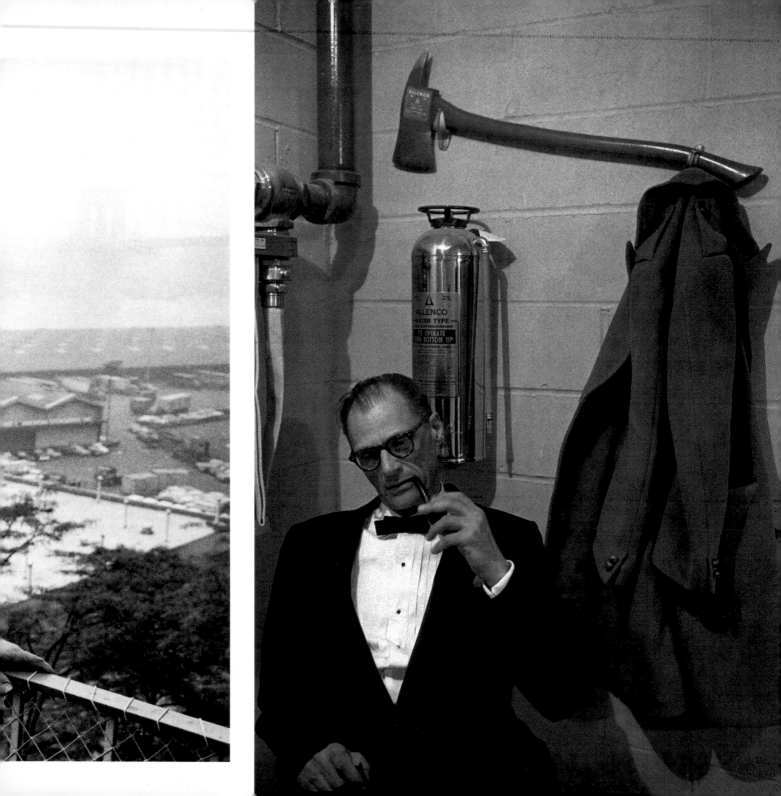

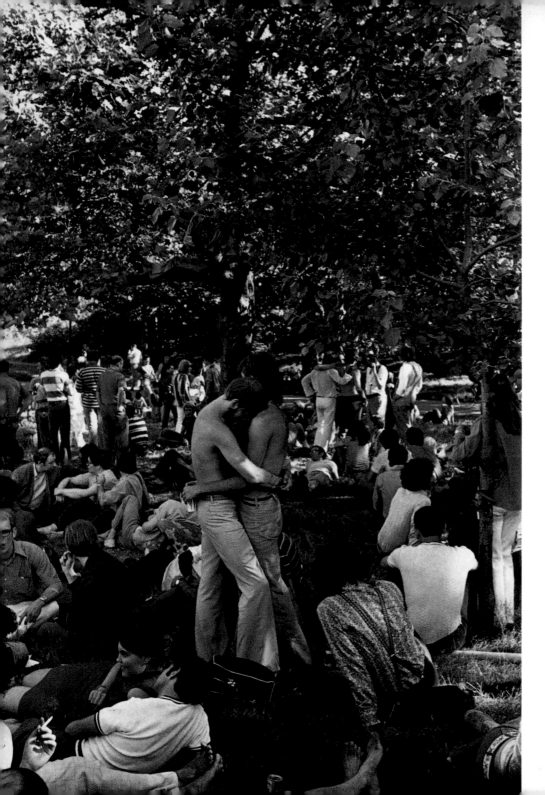
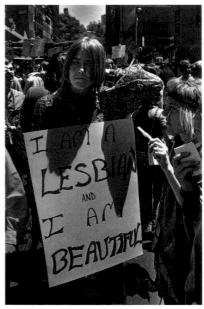
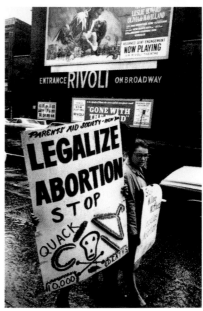

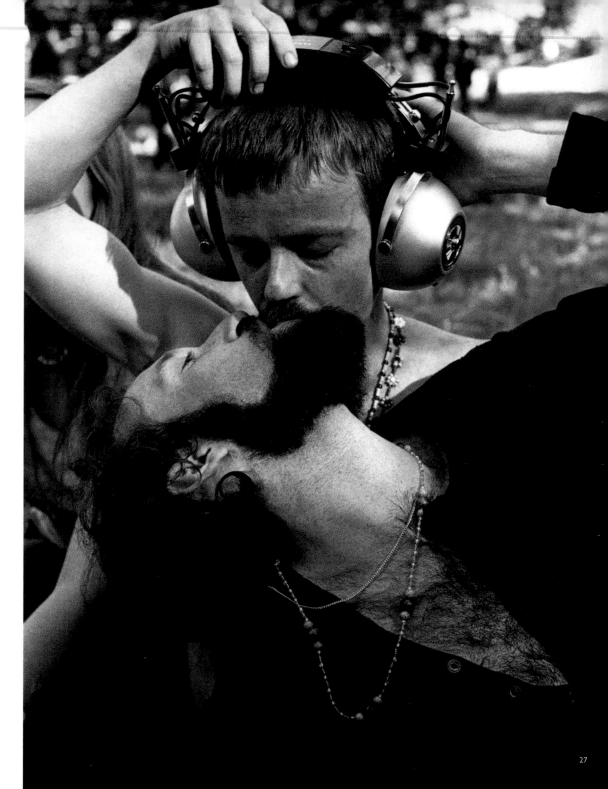

Far left: The warm, gay male embrace

Left: Cries to legalize homosexuality (top) and abortion (below)

Right: Hairy lips meet

Overleaf: Harlem's prime entertainment venue (left). And right, on the town

27

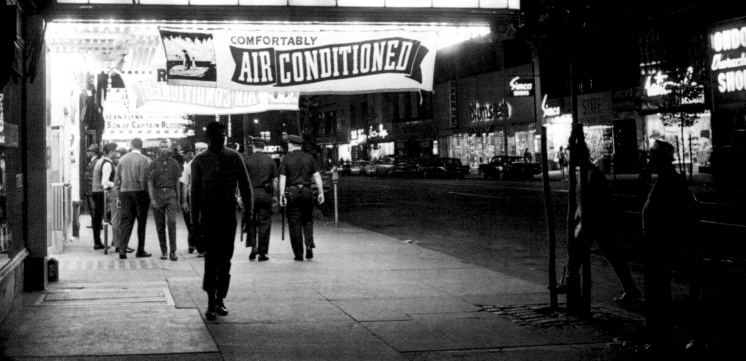

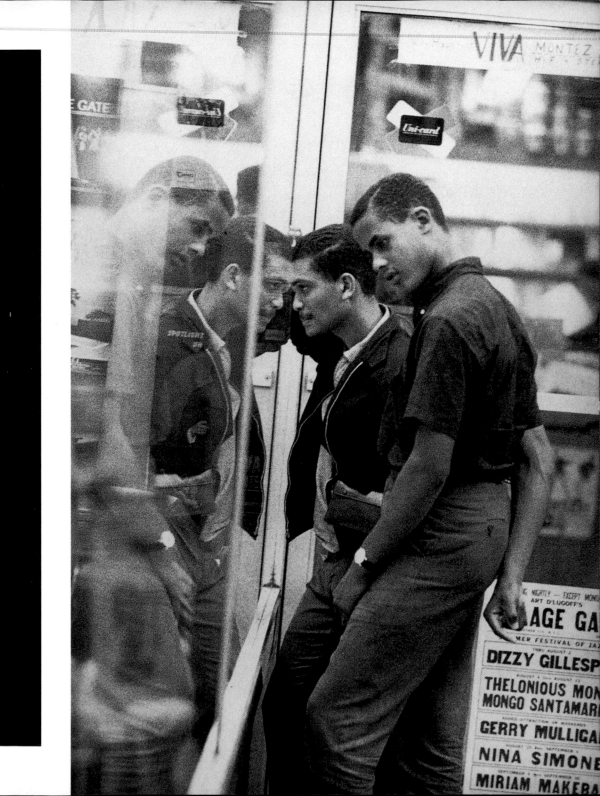

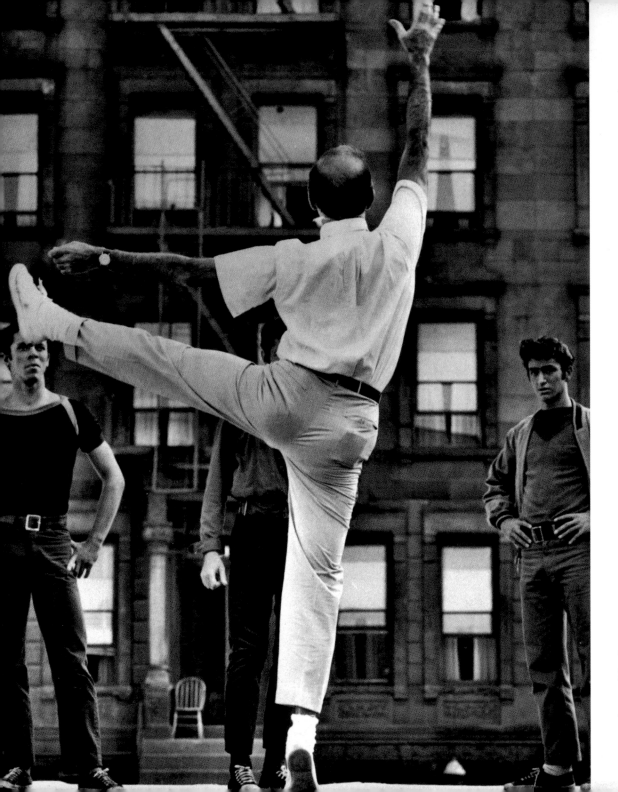

Choreographer
Jerome Robbins
on the West Side

Right: Twistin'
the night away

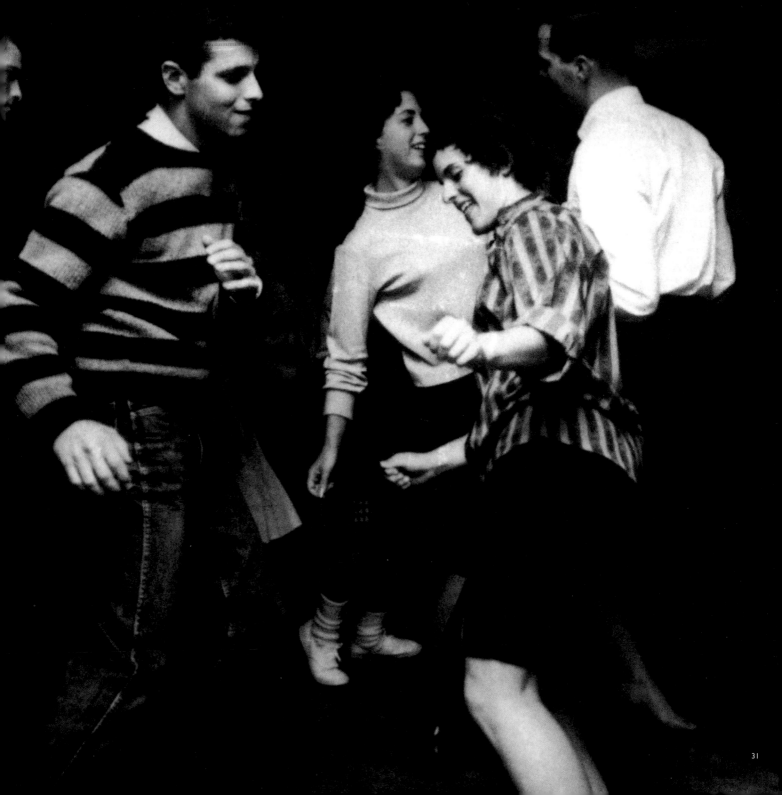

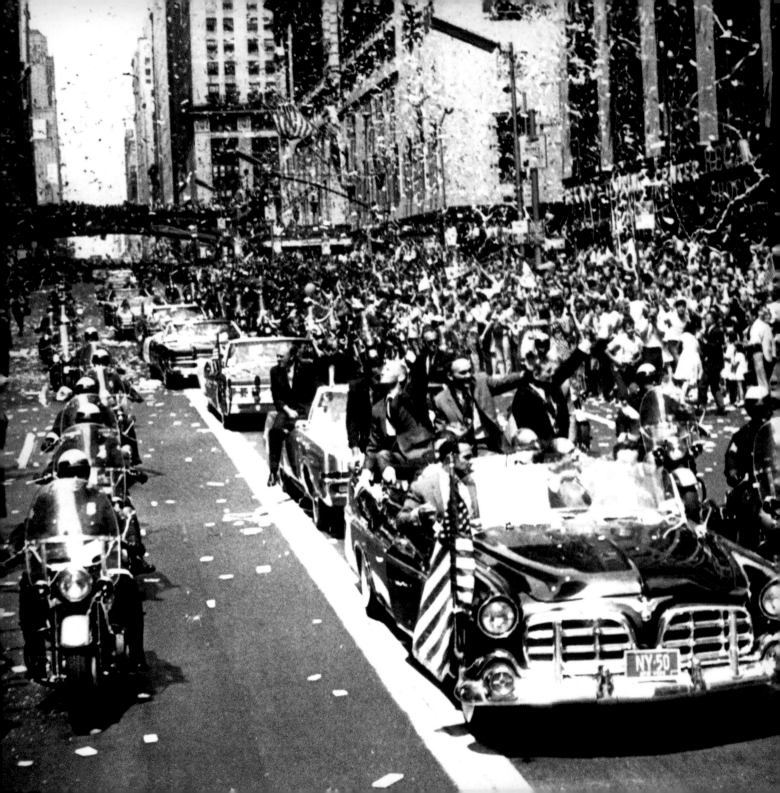

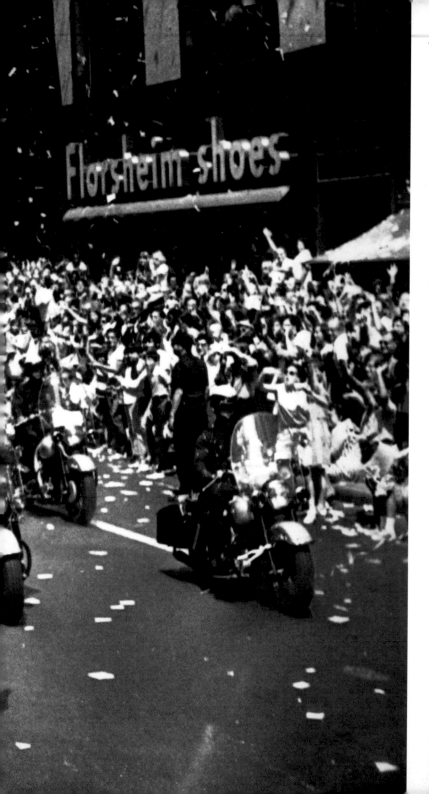

Left: Welcome to the men from the Moon

Below: Willie Mays honoured at the Polo Grounds

Bottom: Baseball star Joe DiMaggio at Yankee Stadium

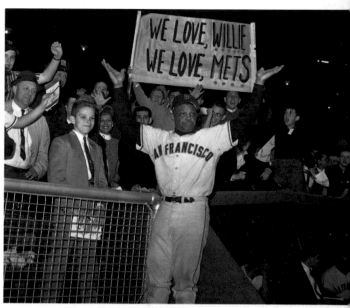

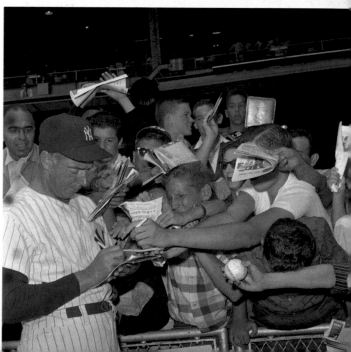

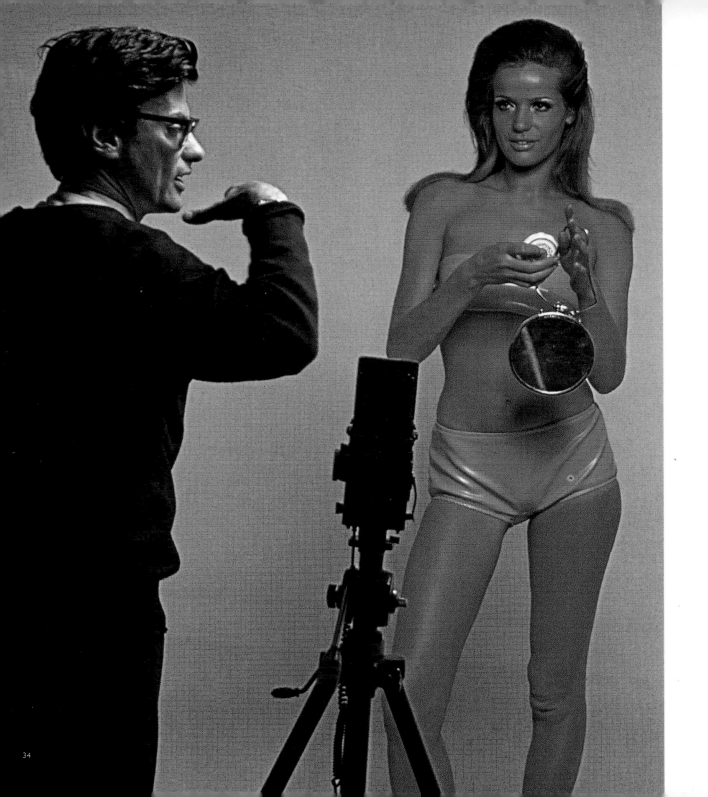

Left: Richard Avedon and model

Below: Music on the street – Hispanic records in Harlem

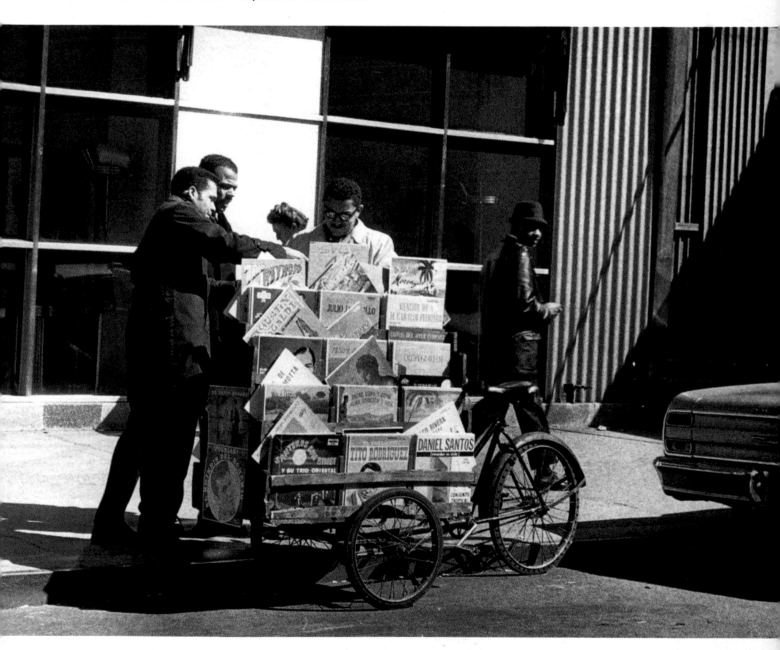

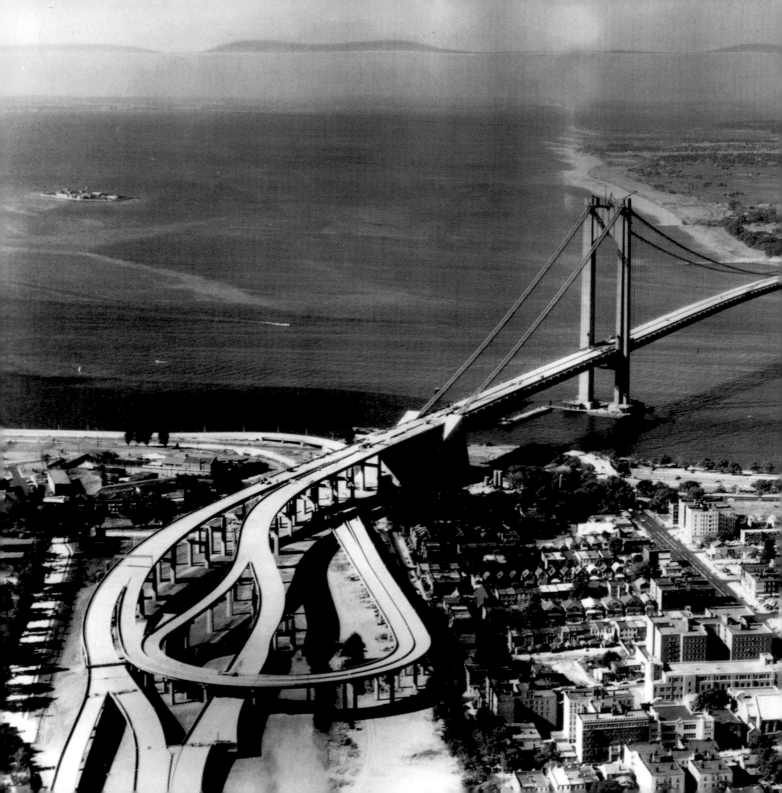

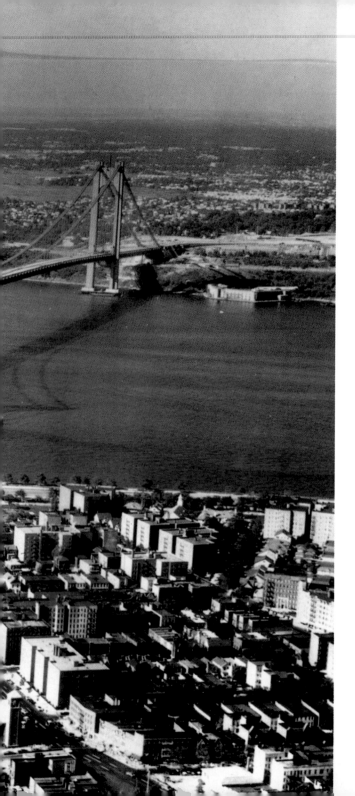

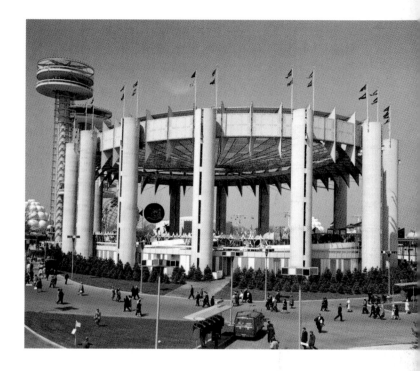

Above: The World's Fair of 1964

Left: The Narrows Bridge opens

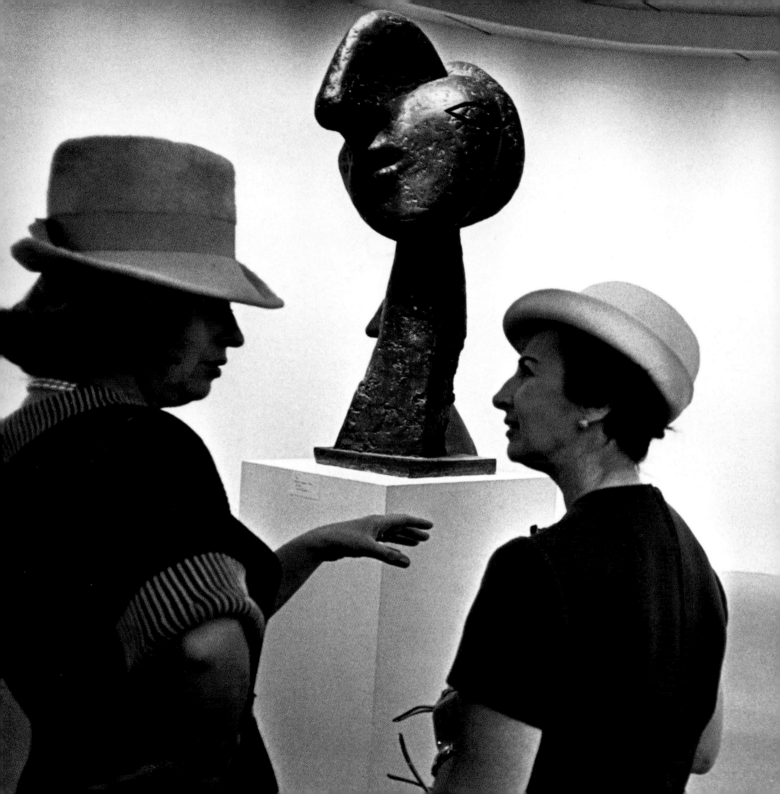

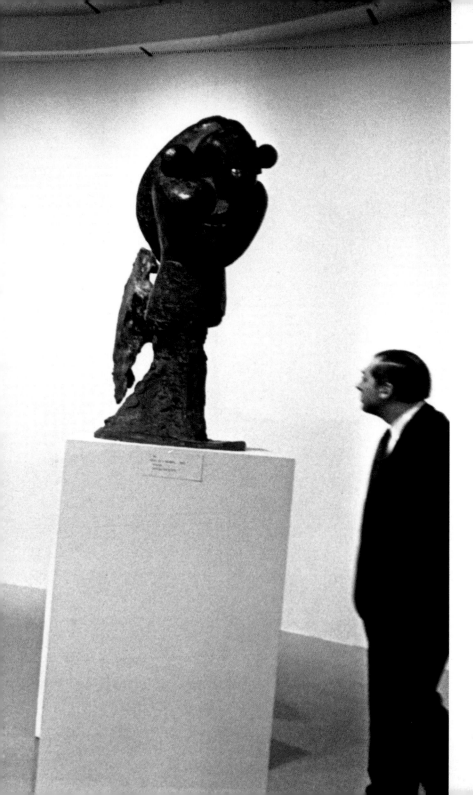

Picasso on show

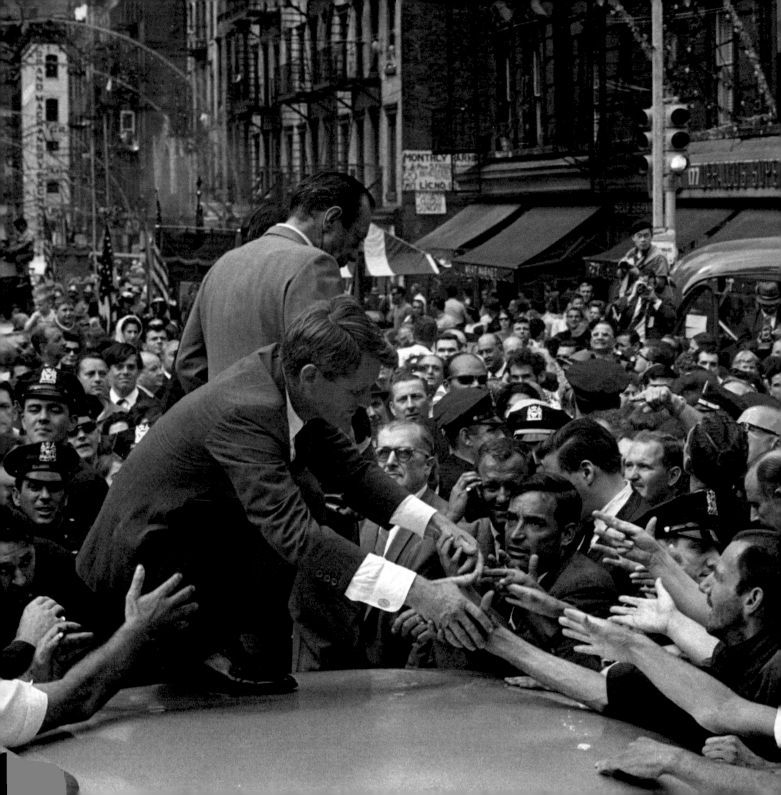

Bobby Kennedy campaigns for Robert Wagner

Overleaf: JFK and Jackie go after the Presidency (left). Nixon on the campaign trail in 1960 (right)

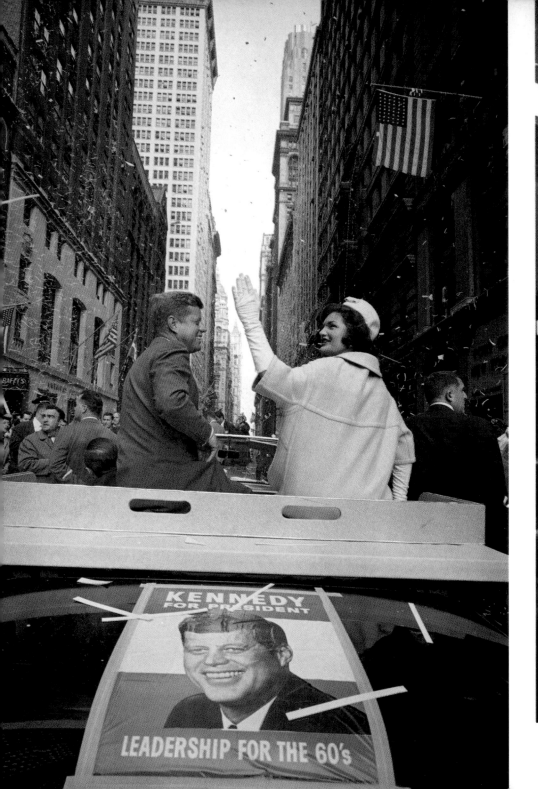
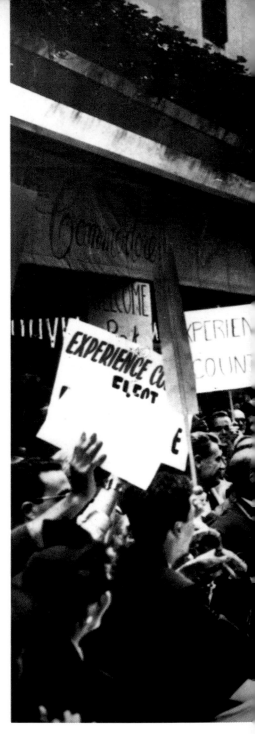

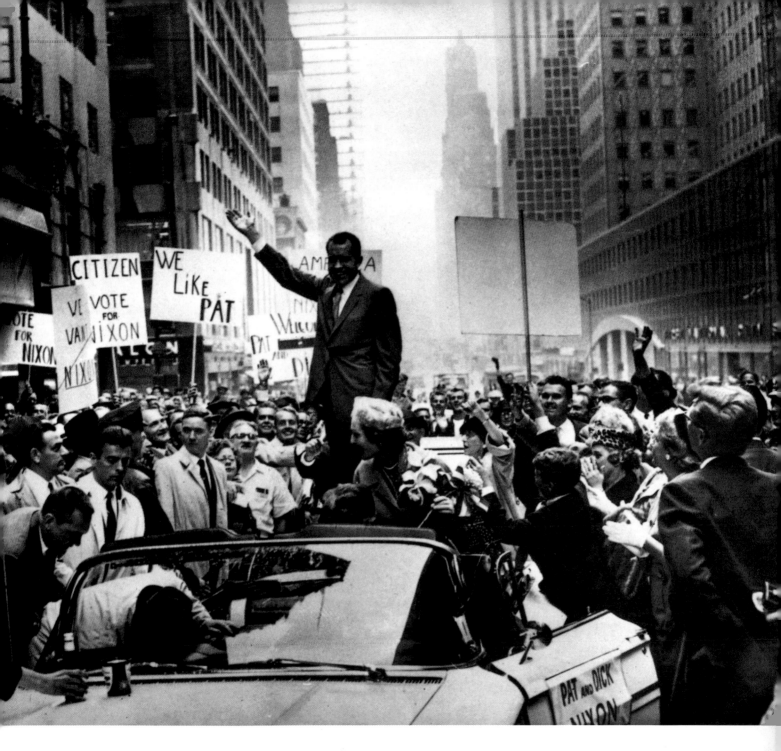

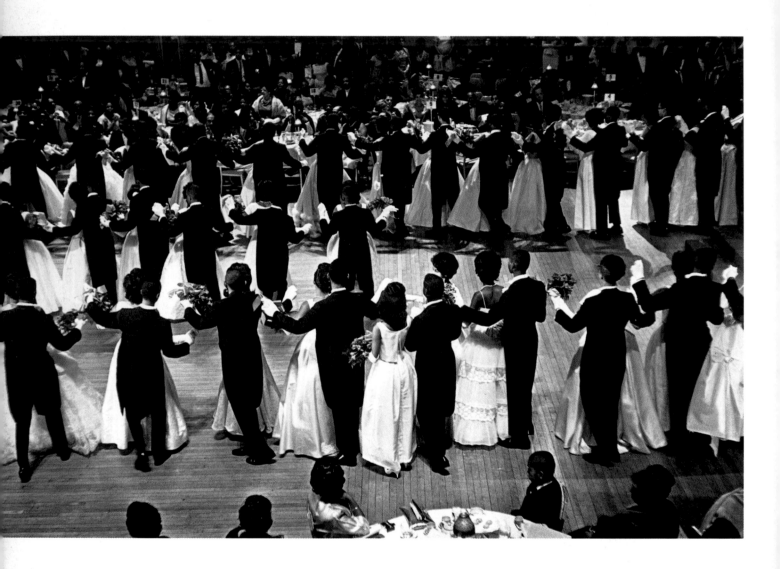

Above: Black debs have a ball

Right: In remembrance of an assassinated president

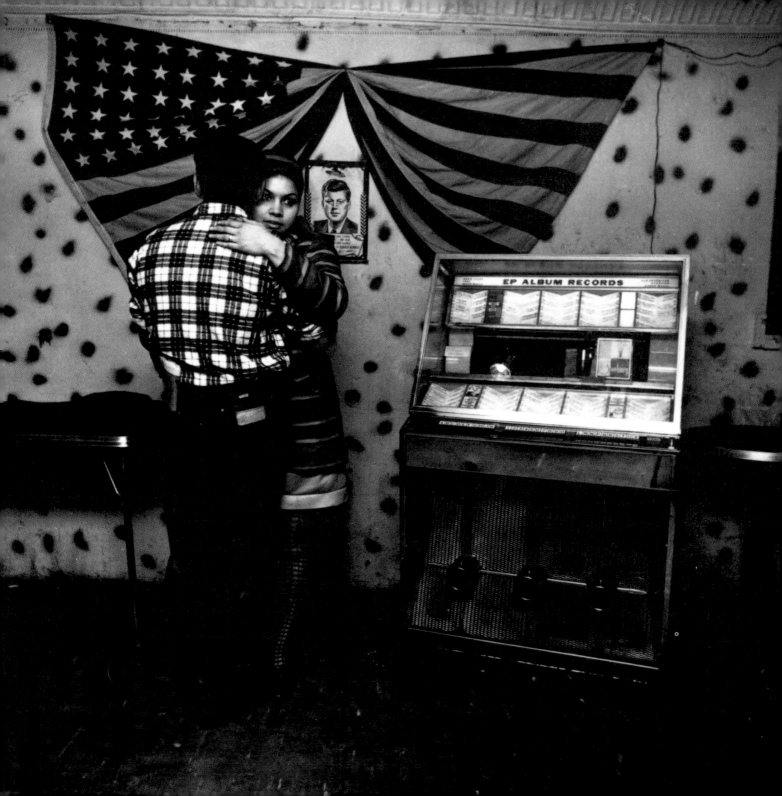

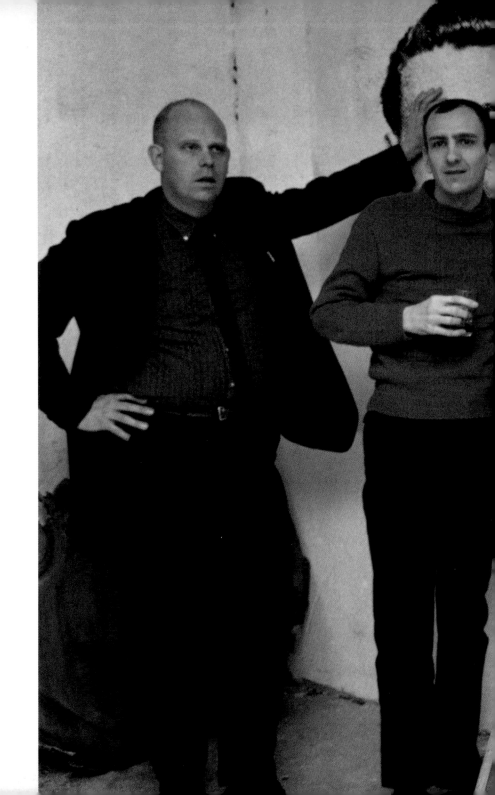

The artists and the model

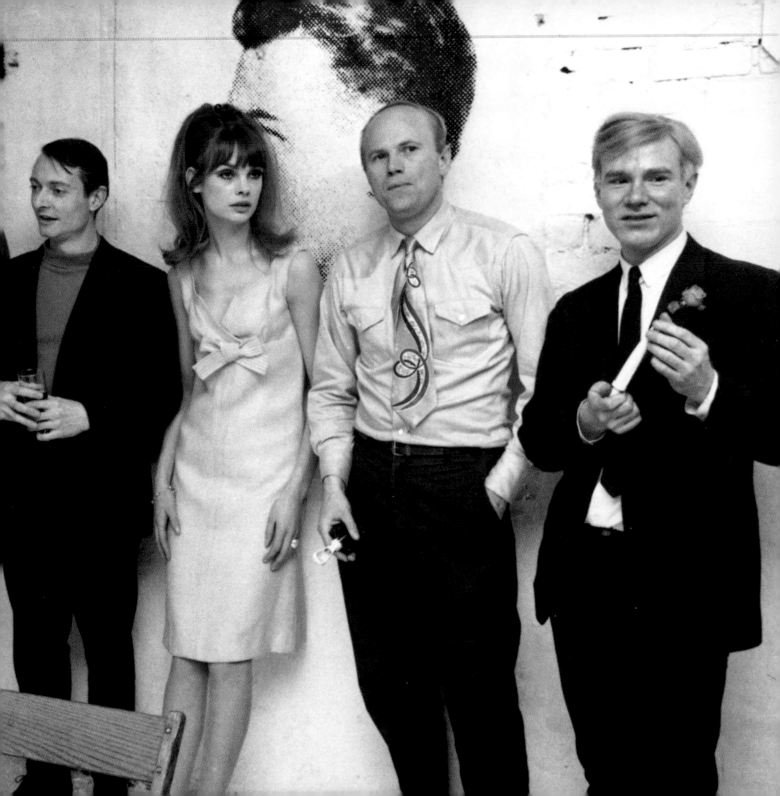

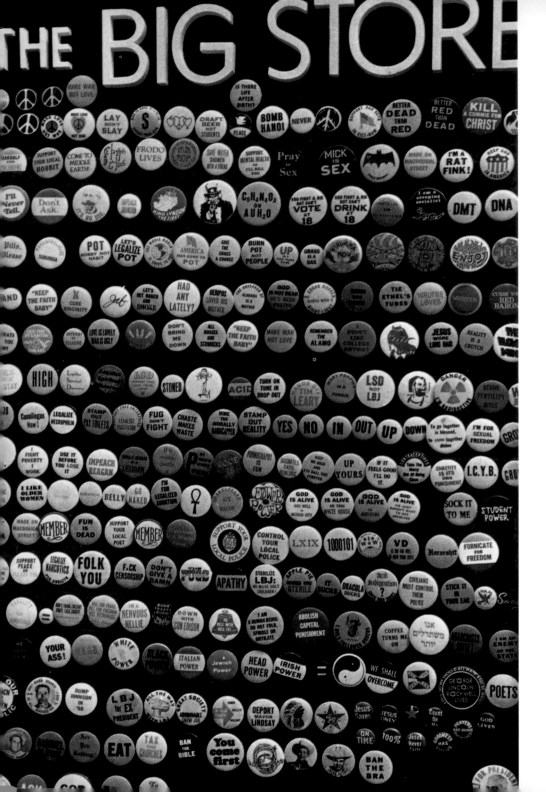

Left: Buttons by the score

Right: Black balloons in a Vietnam protest

Overleaf: Conductor Leonard Bernstein in action

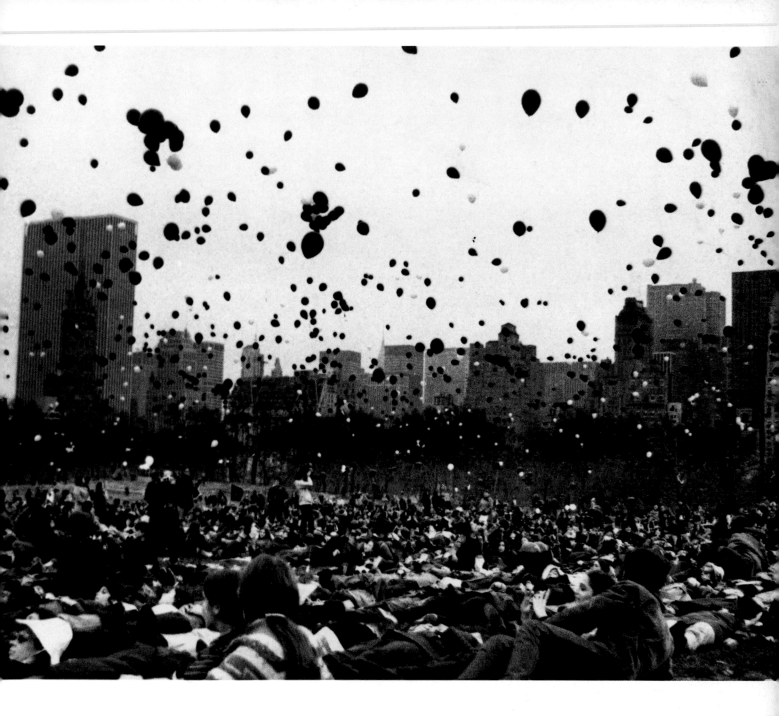

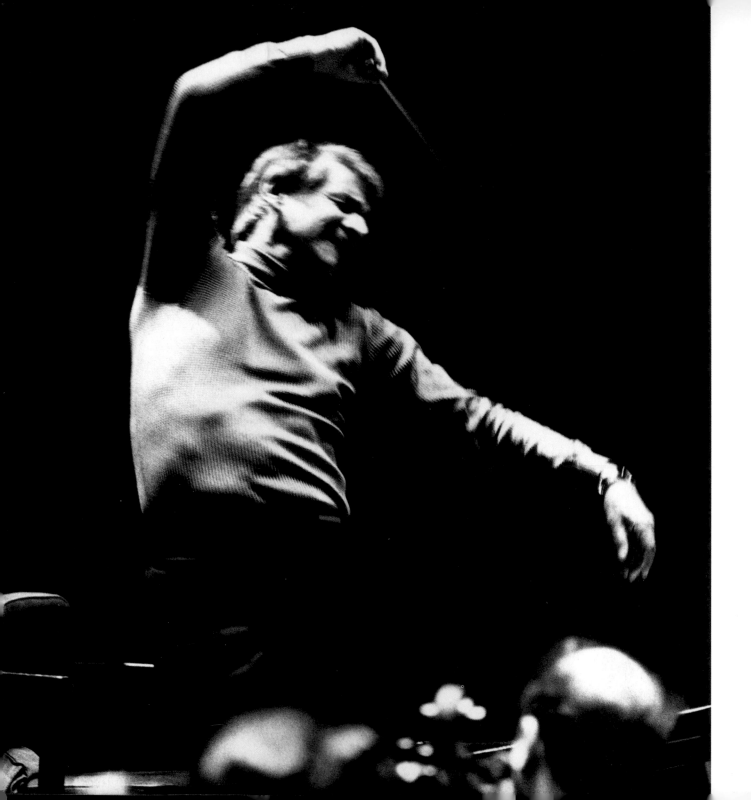

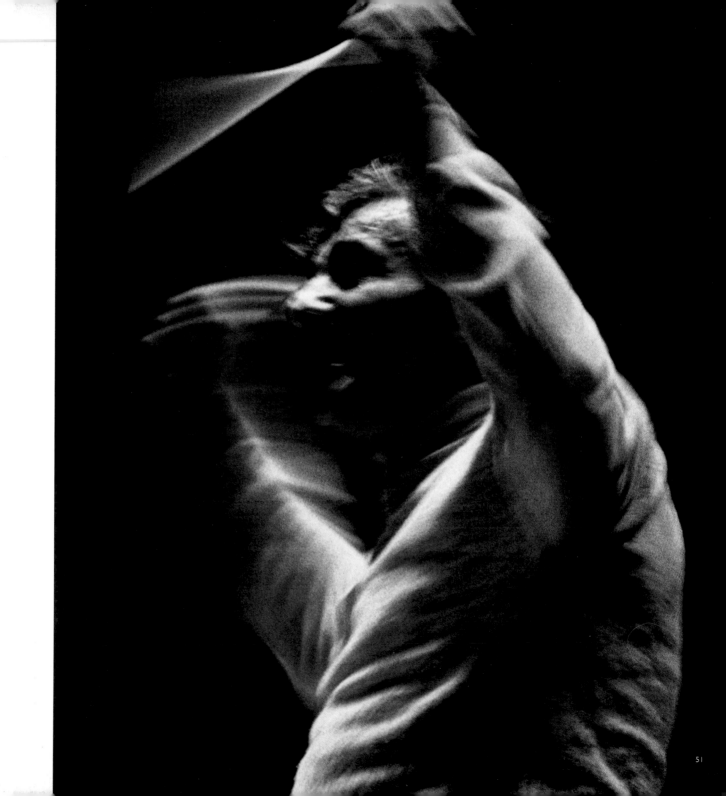

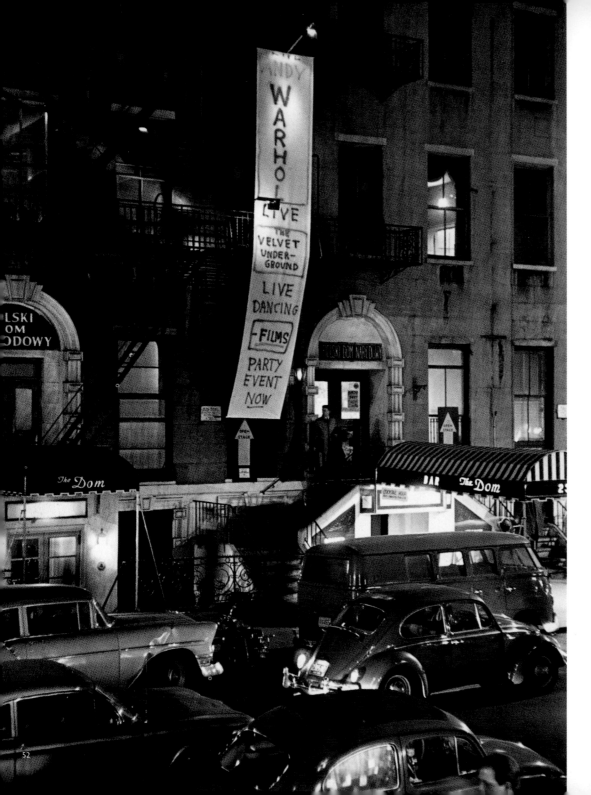

Left: Warhol's
'Exploding Plastic
Inevitable'

Right: The Great
White Way

Far right: 'Funny
Girl', Barbra
Streisand with
husband Elliot Gould

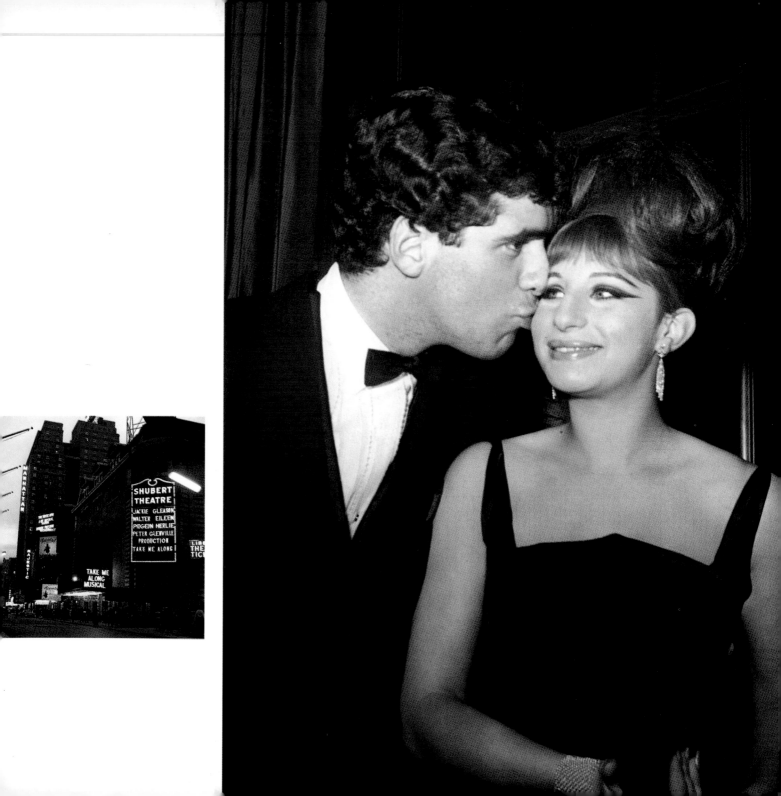

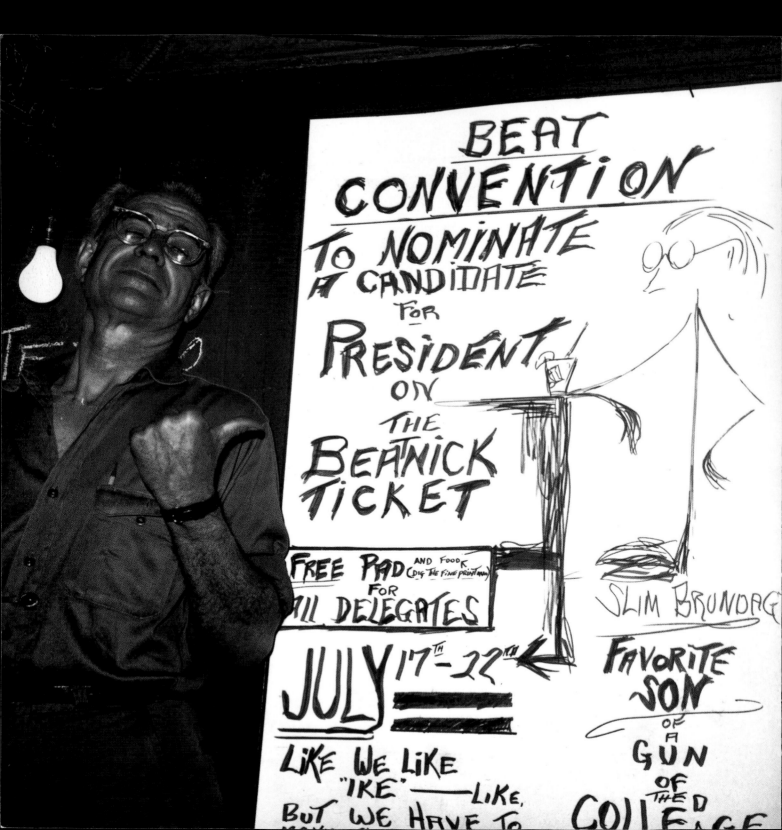

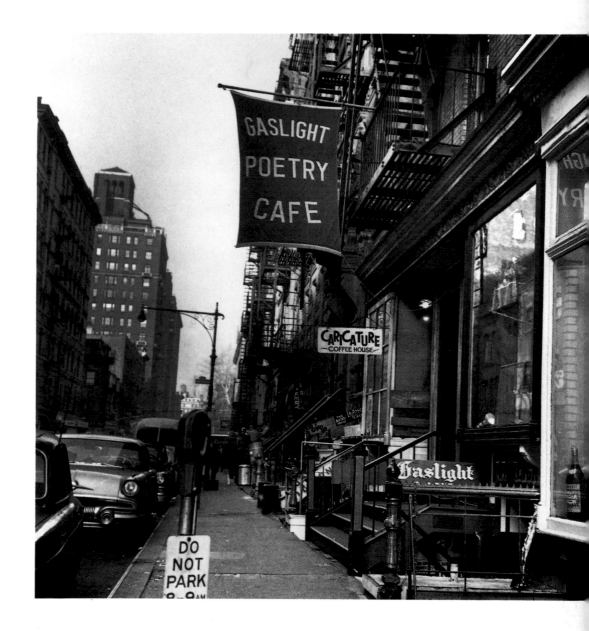

Left: Why shouldn't a beatnik run for President?

Right: Poets' corner

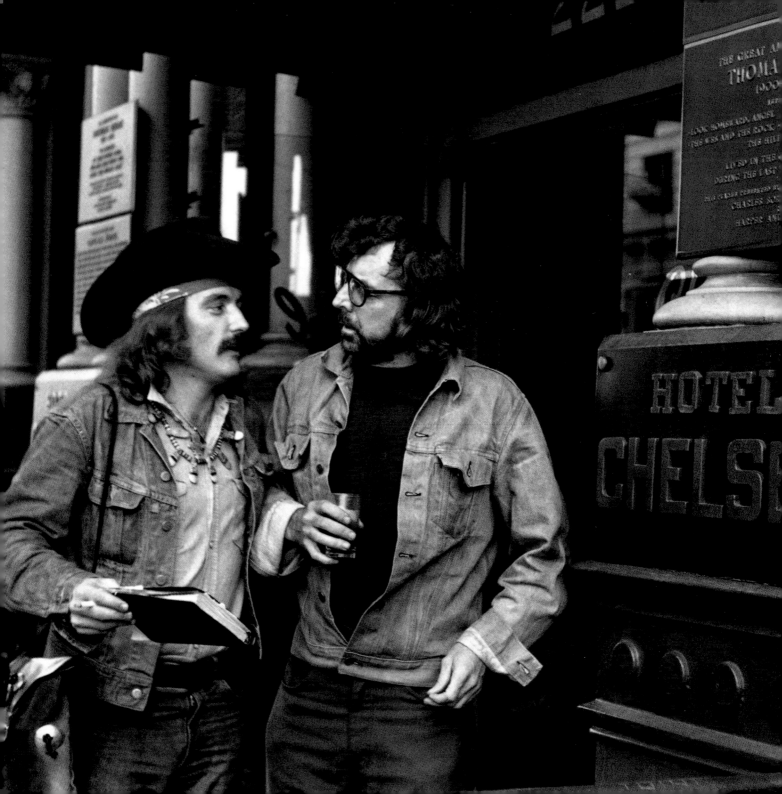

Left: Actor Dennis Hopper and writer Terry Southern at the Chelsea Hotel

Below: Timothy Leary Turns On, Tunes In, Drops Out

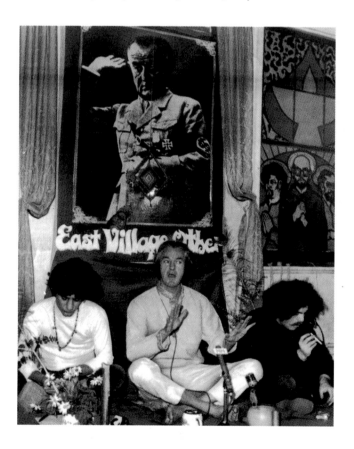

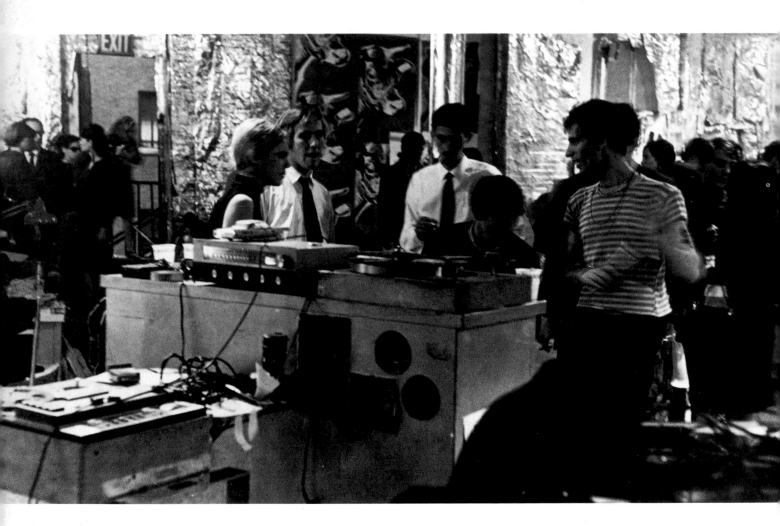

Above: Andy parties **Right: Underground cinema**

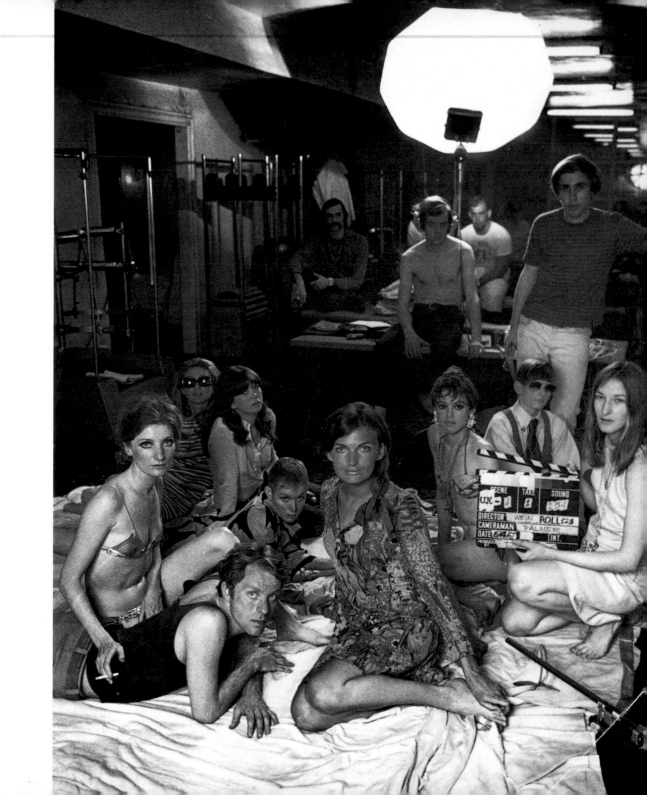

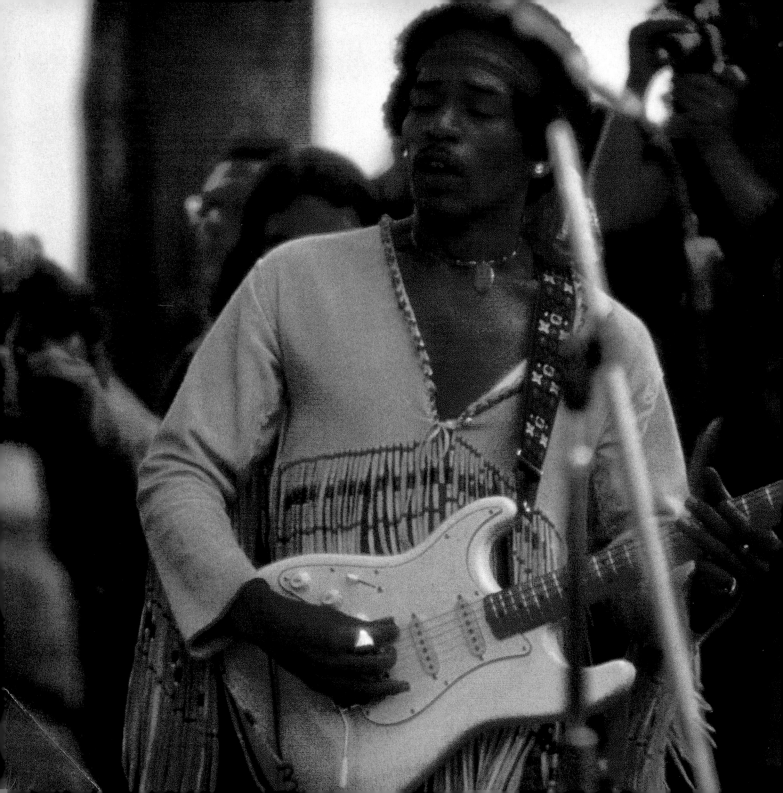

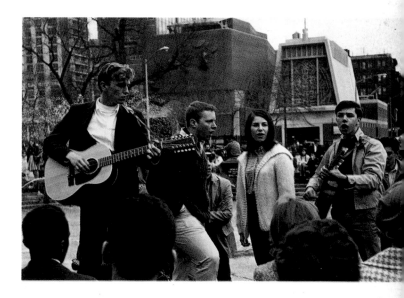

Above: Songs in the square

Left: Rock Star Jimi Hendrix at Woodstock

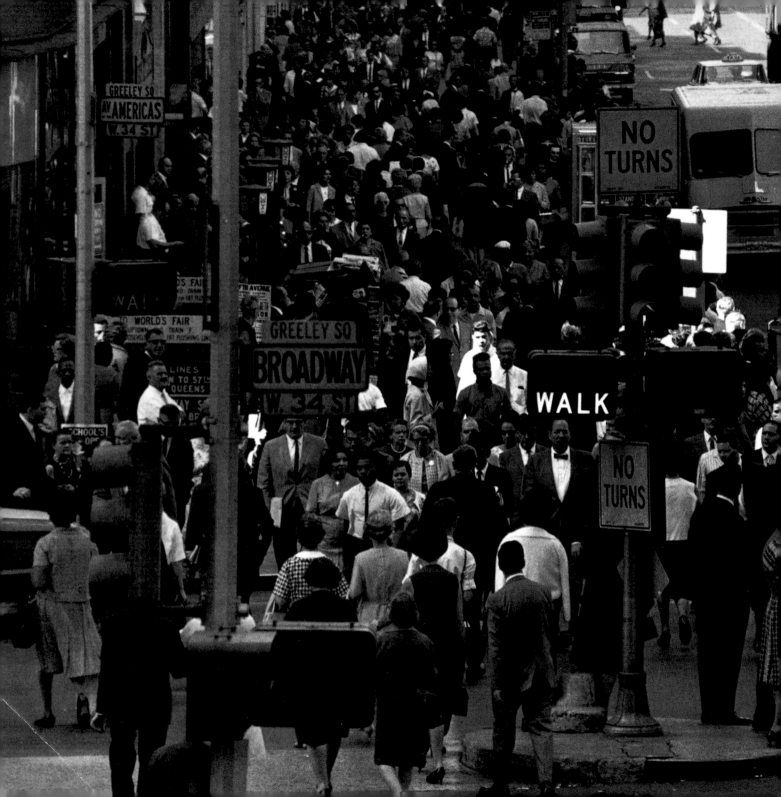

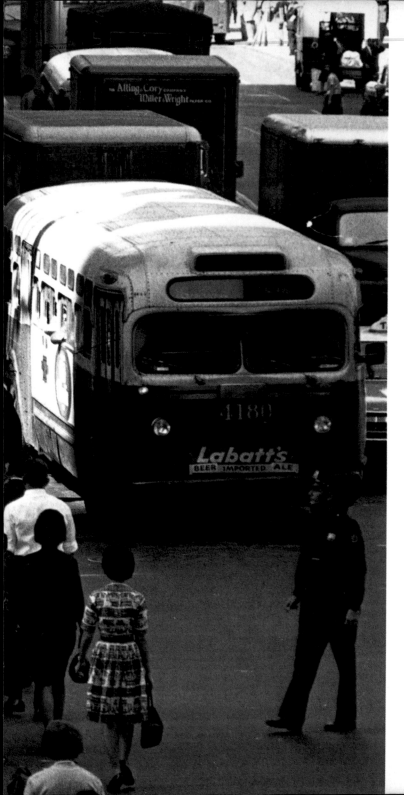

Left: The passing crowd

Below: Passing the word

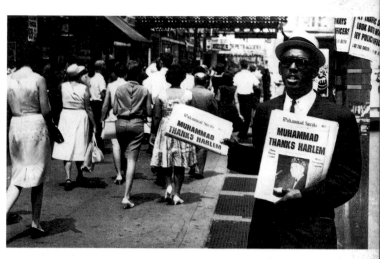

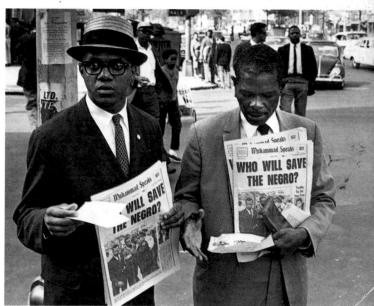

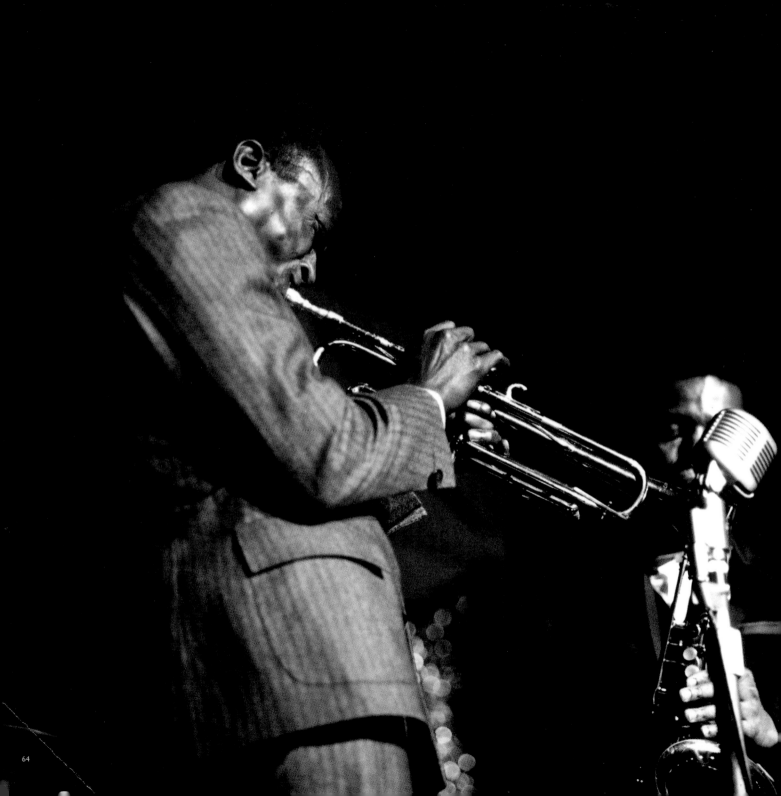

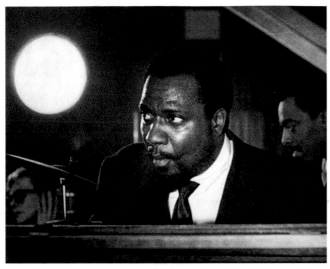

Jazz greats perform

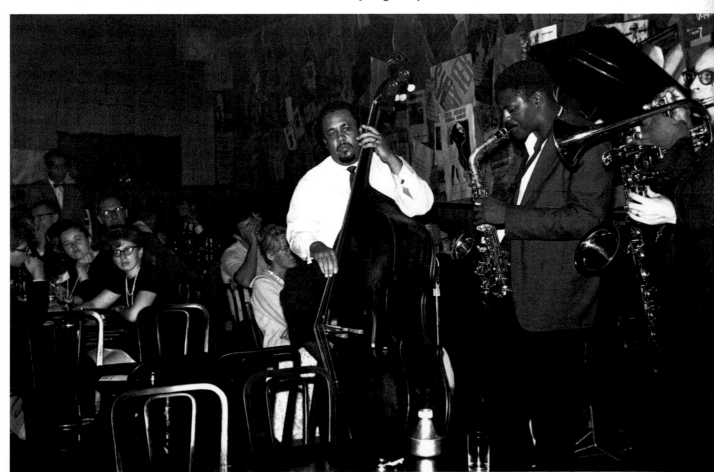

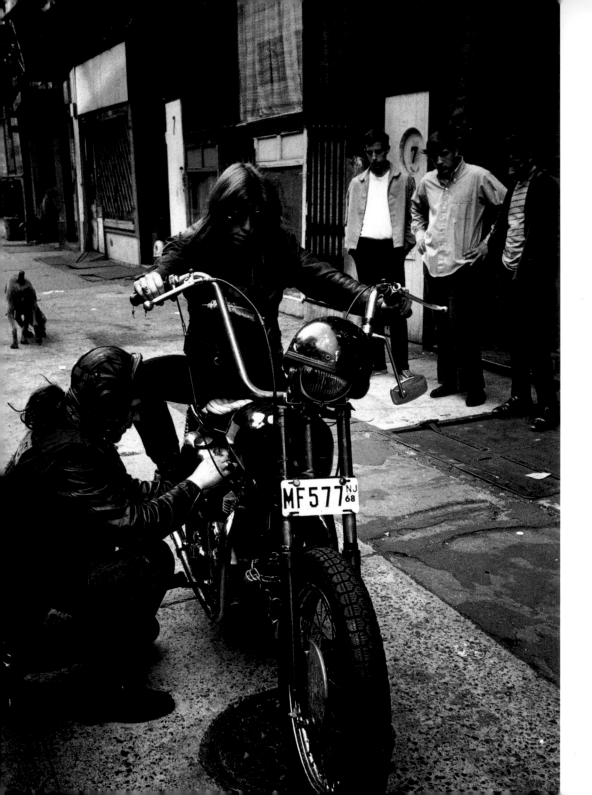

Left: Biker style

Right: Flower power

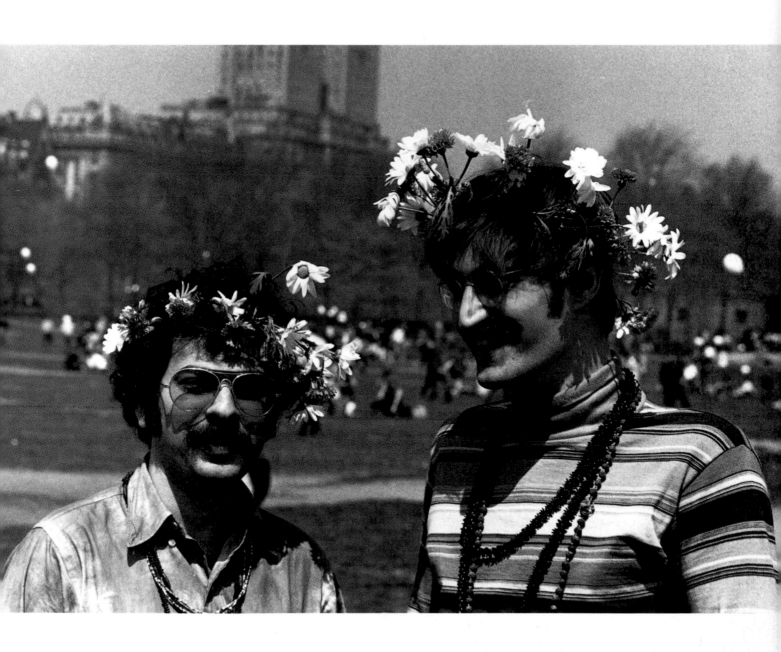

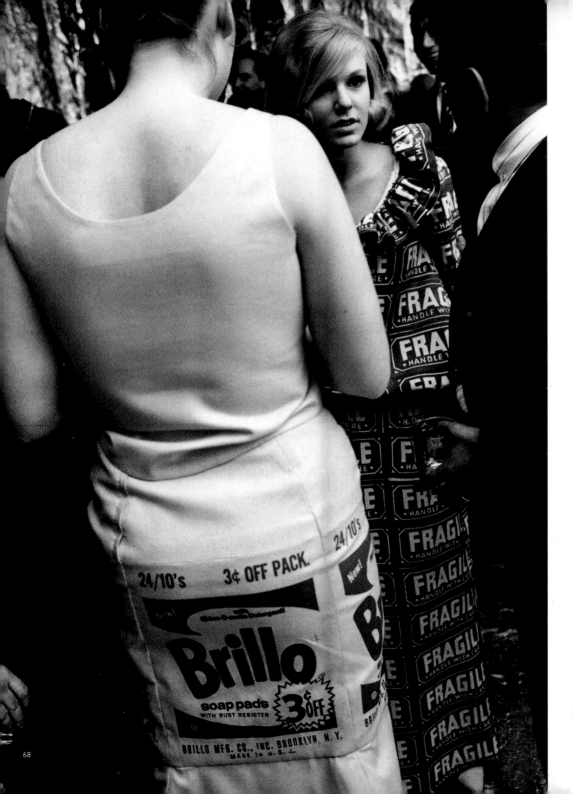

68

Left: Pop art dresses

Right: Willem de Kooning draws a puff

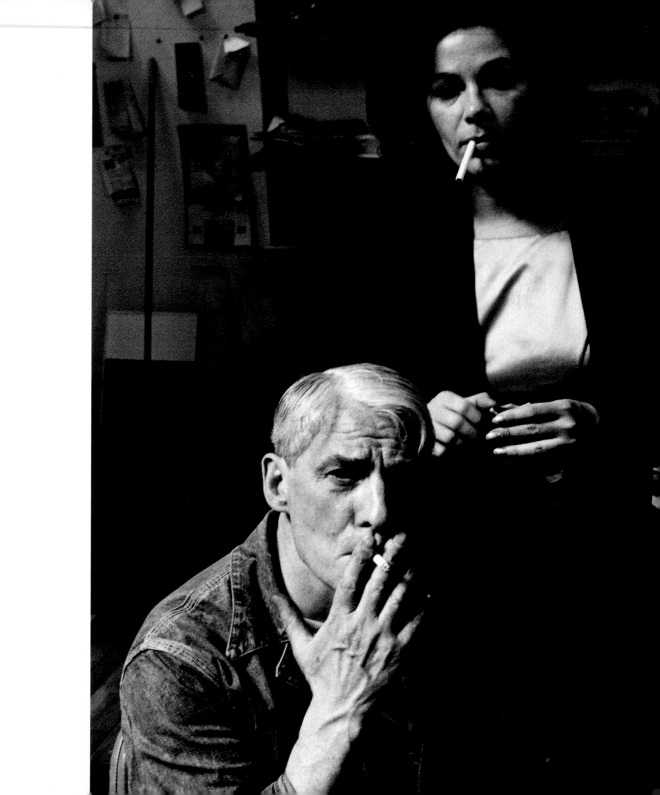

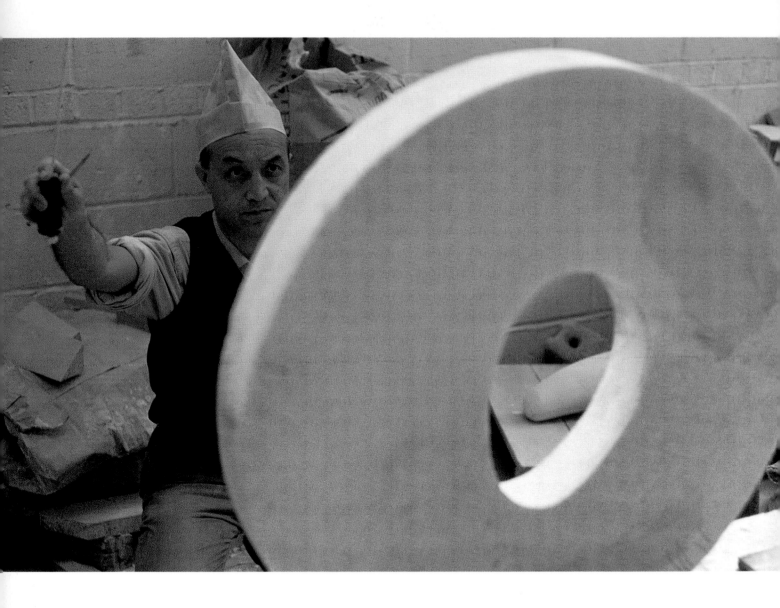

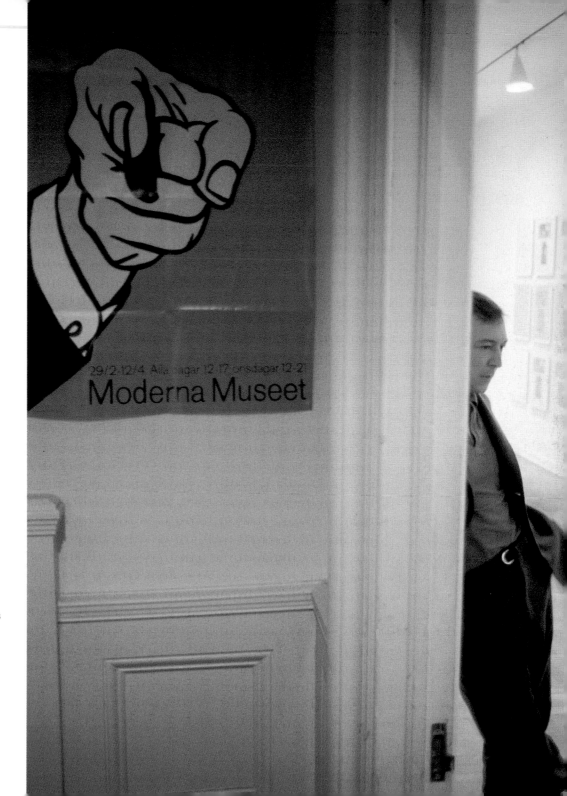

Left: Artist Noguchi and his sculpture

Right: Artist Jasper Johns shrinks from view

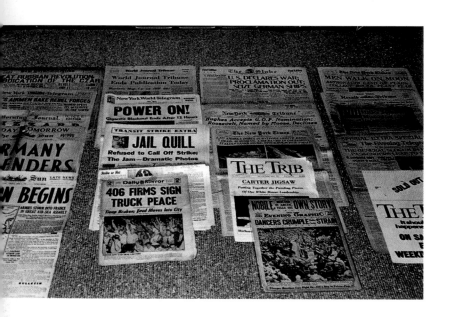

Above: Strike action

Right: Comedian Lenny
Bruce – shocking the
unshockable

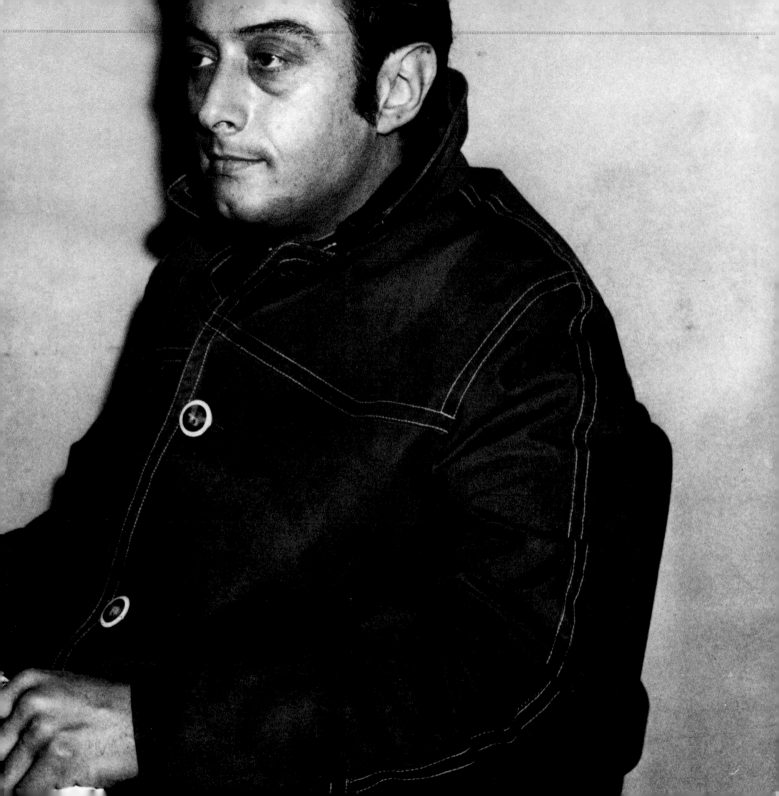

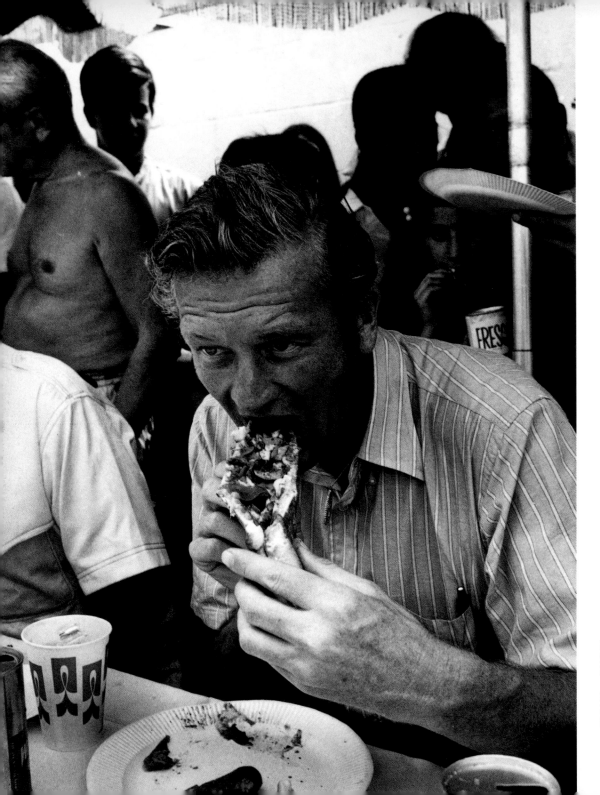

Left: Quick lunch
for Mayor
Lindsay

Right: Mayor
Lindsay addresses
his followers

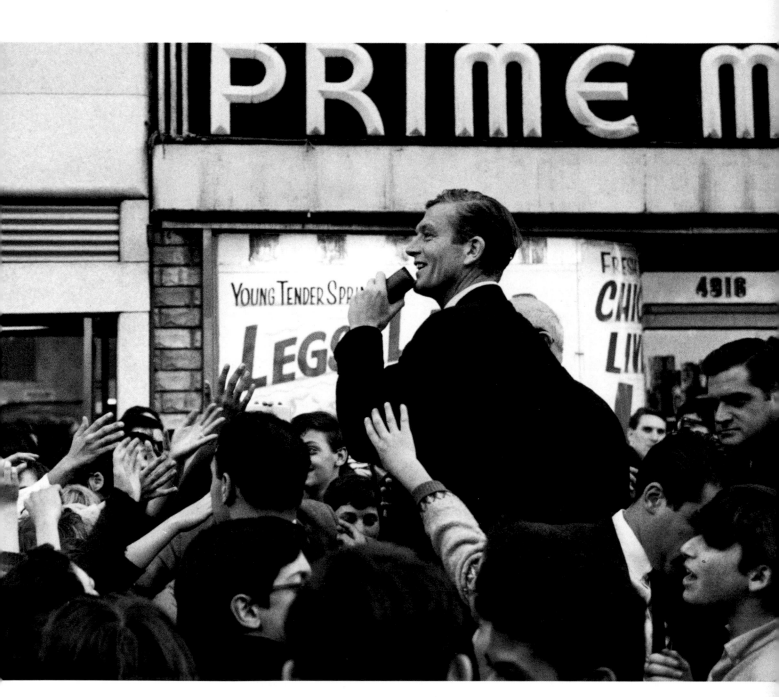

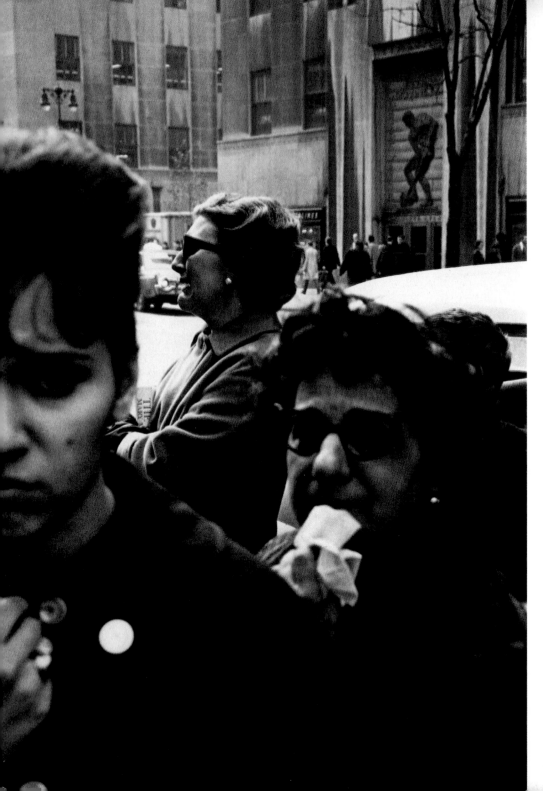

Left: Death of a President

Right: Death of a station

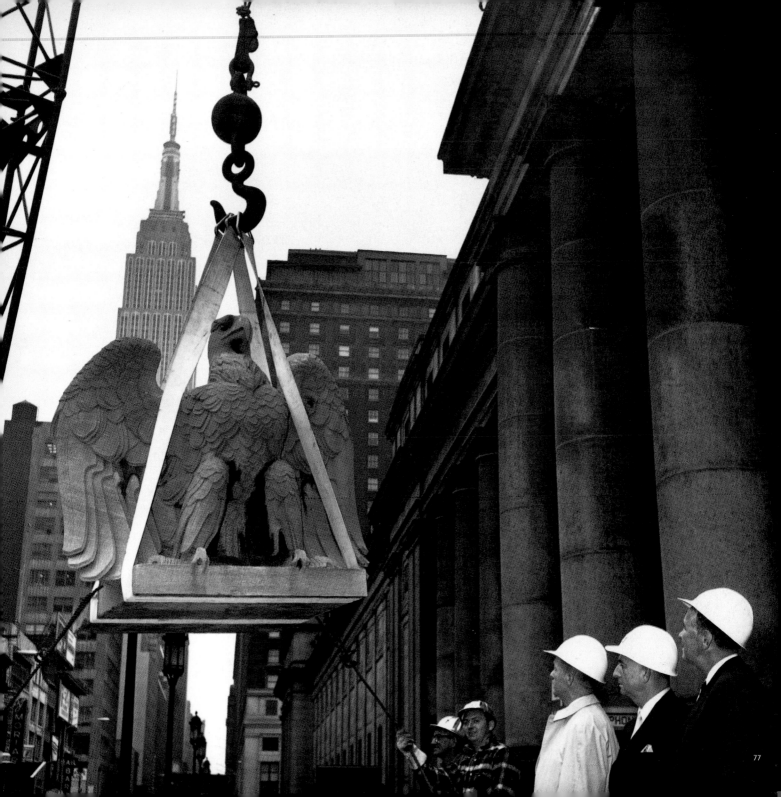

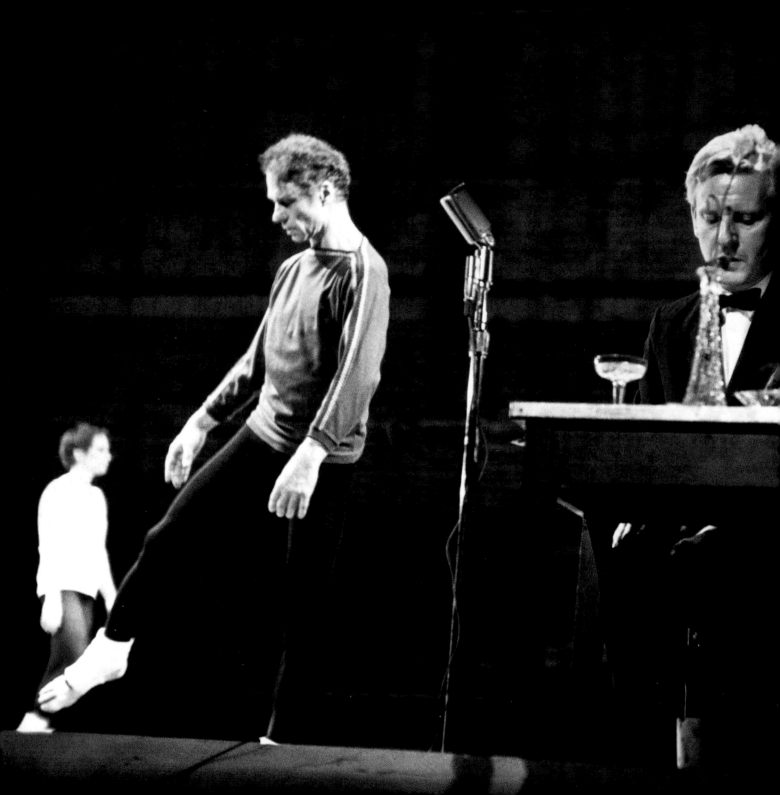

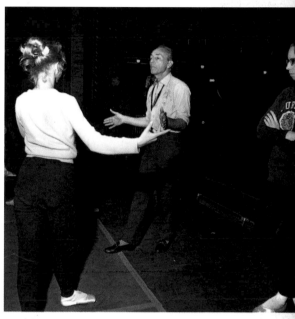

Above: On with the dance – George Balanchine in rehearsal

Left: Dancer Merce Cunningham in performance

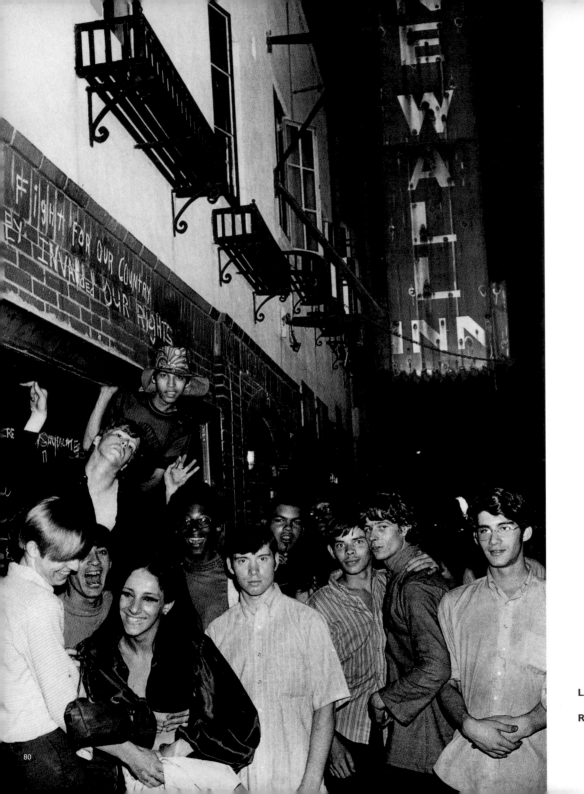

Left: Stonewall riots begin

Right: At the Electric Circus

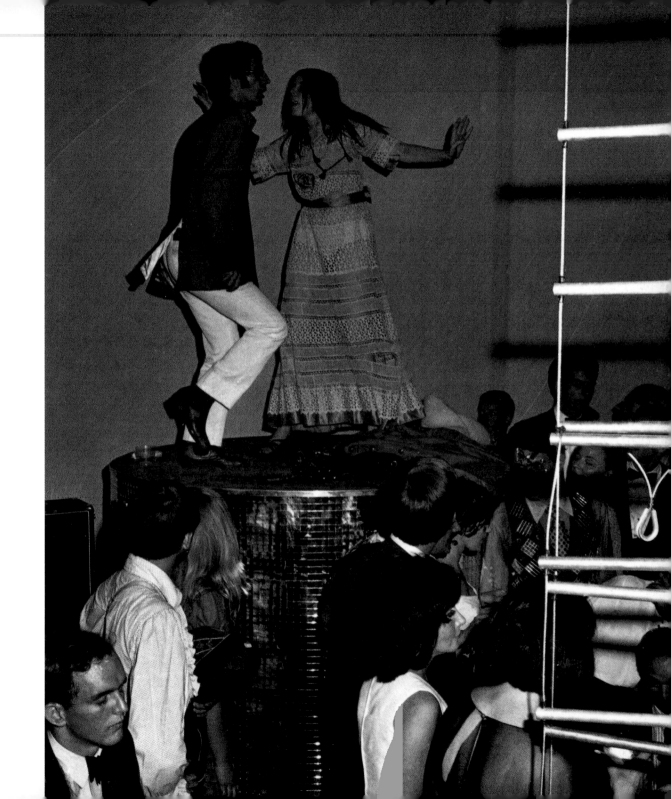

Right: 'Turn On, Tune In, Drop Out' is Hippie Guru and Drugs proselytizer Timothy Leary's message

Below: Betty Friedan, the top feminist

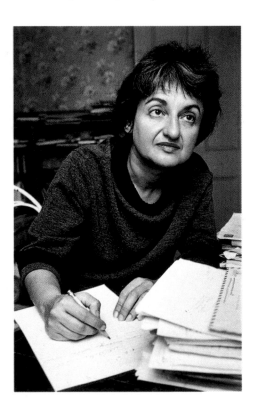

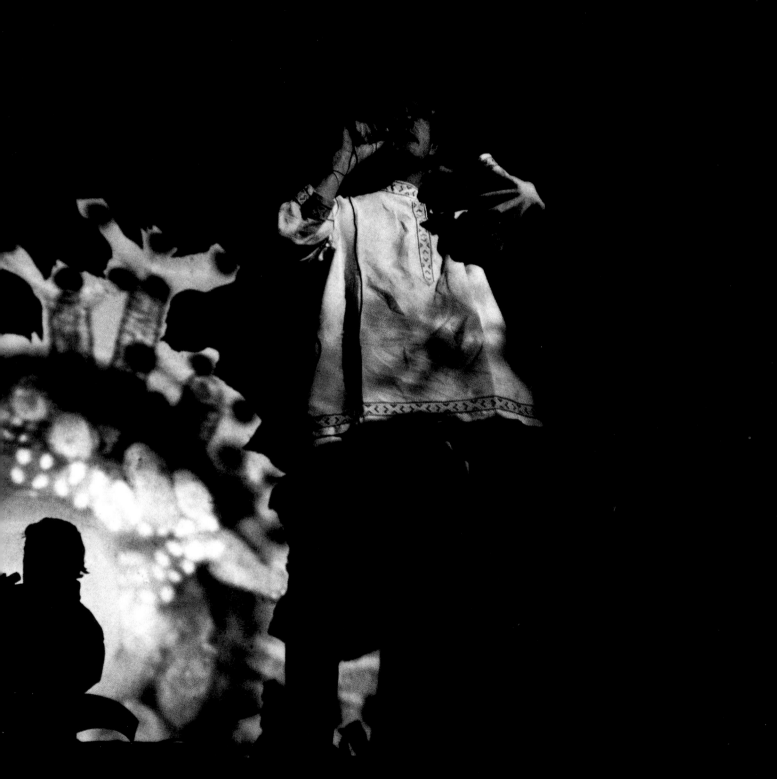

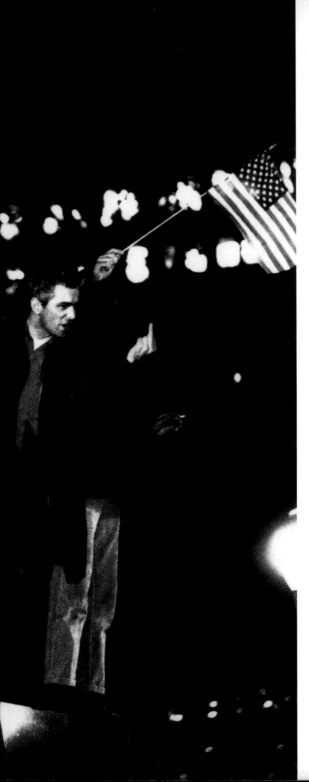

Left: Peace protest in Bryant Park

Right: Mini in Manhattan

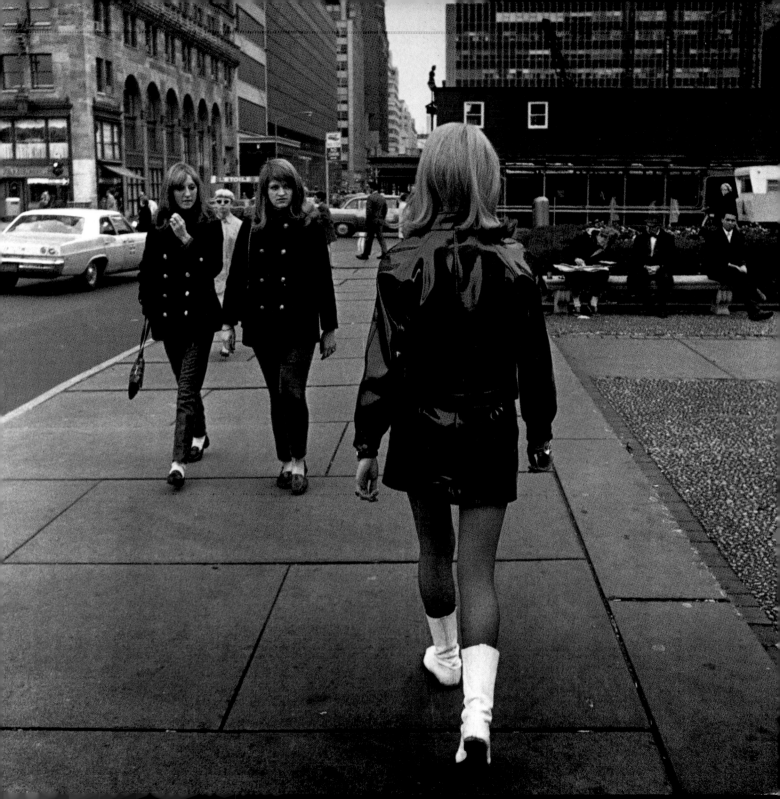

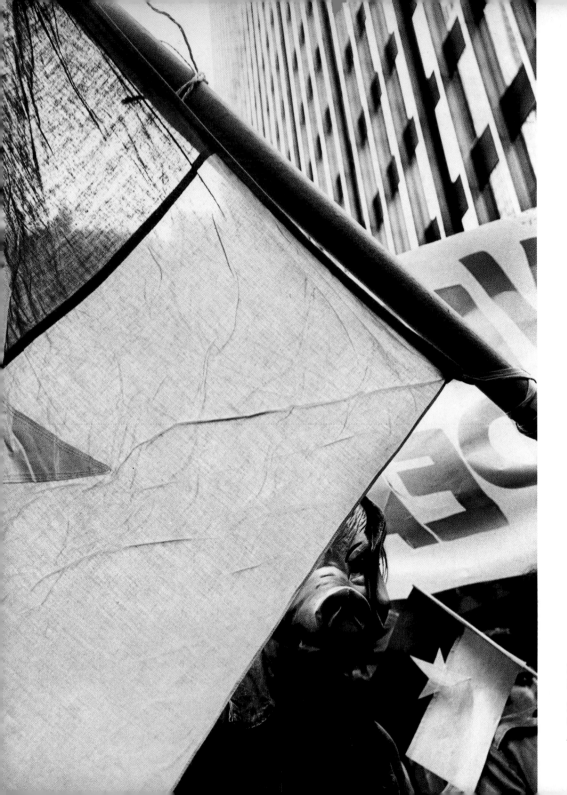

Left: Anti-Vietnam War,
pro-Castro, Cuba demo

Right: Gays under
duress, 1962

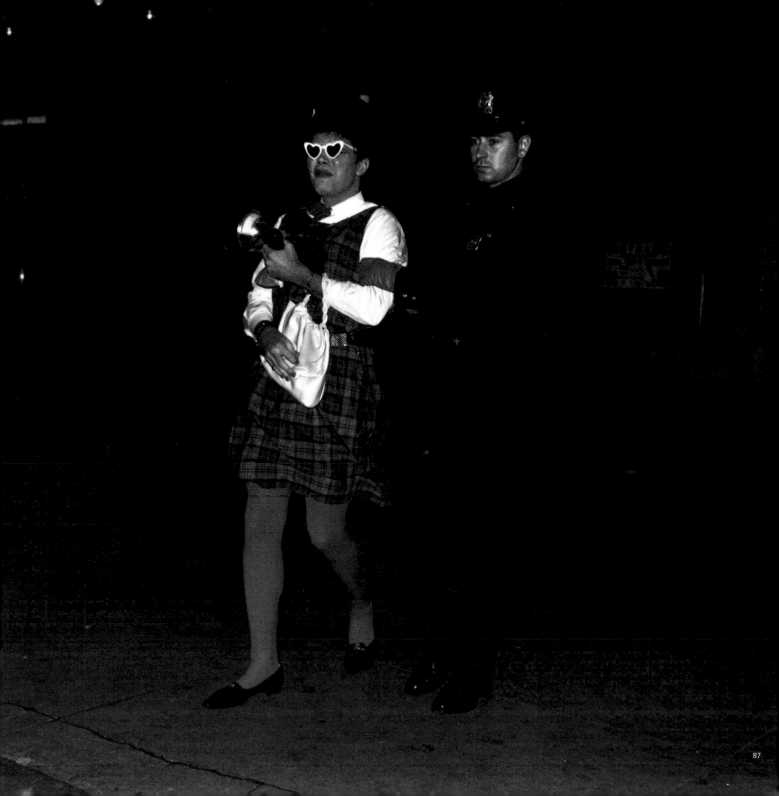

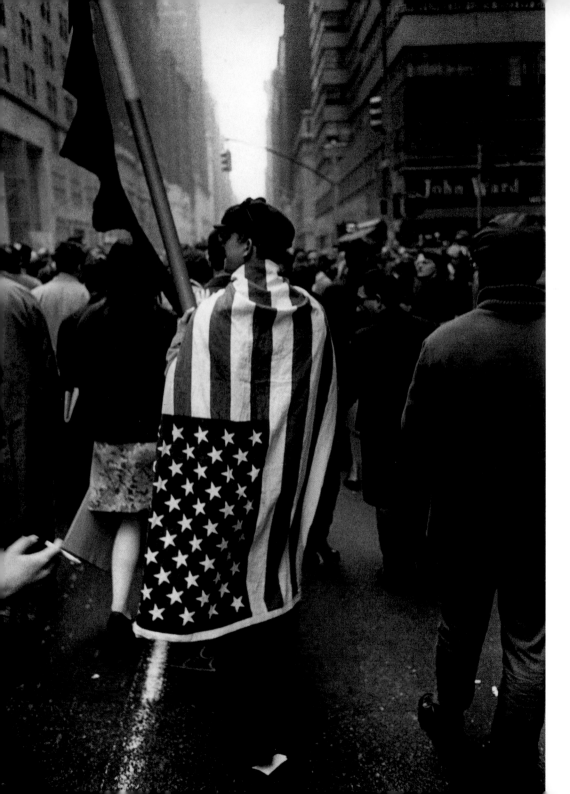

Left: Protest against
the war with an
upside-down flag

Right: Novelist Truman
Capote and Princess
Lee Radziwill dance

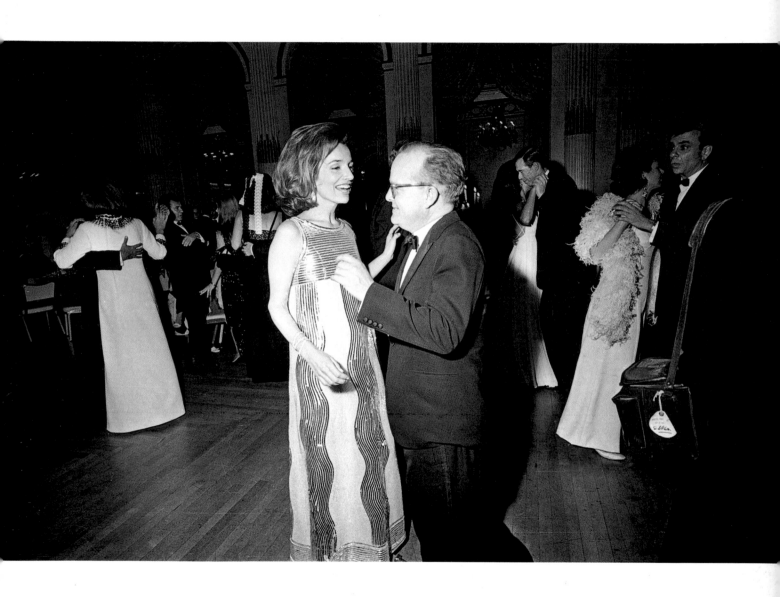

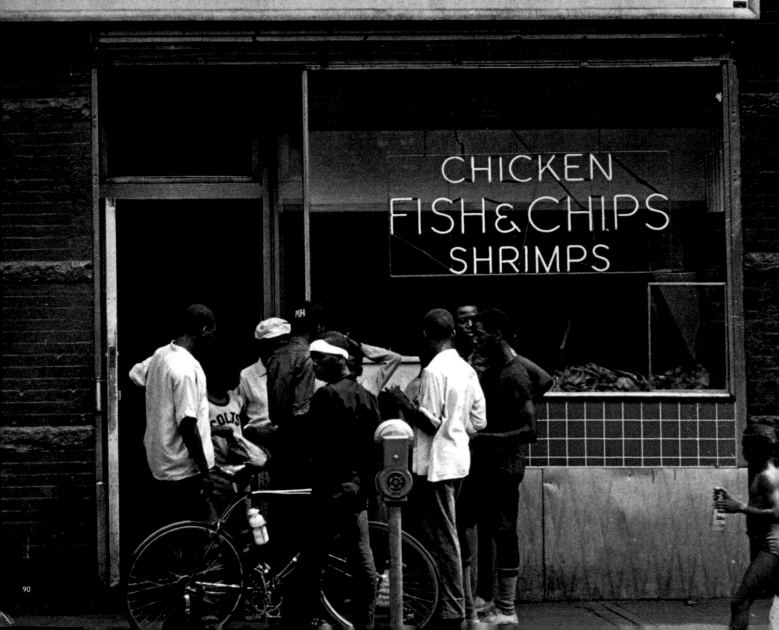

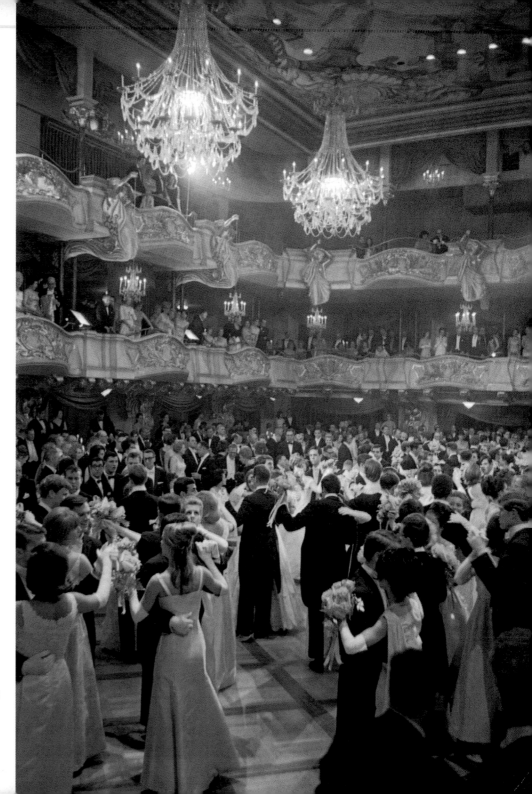

Left: Hangout for Harlem youths

Right: In the Astor ballroom

Overleaf: Revolution on Central Park West (left). Quaker protest (right)

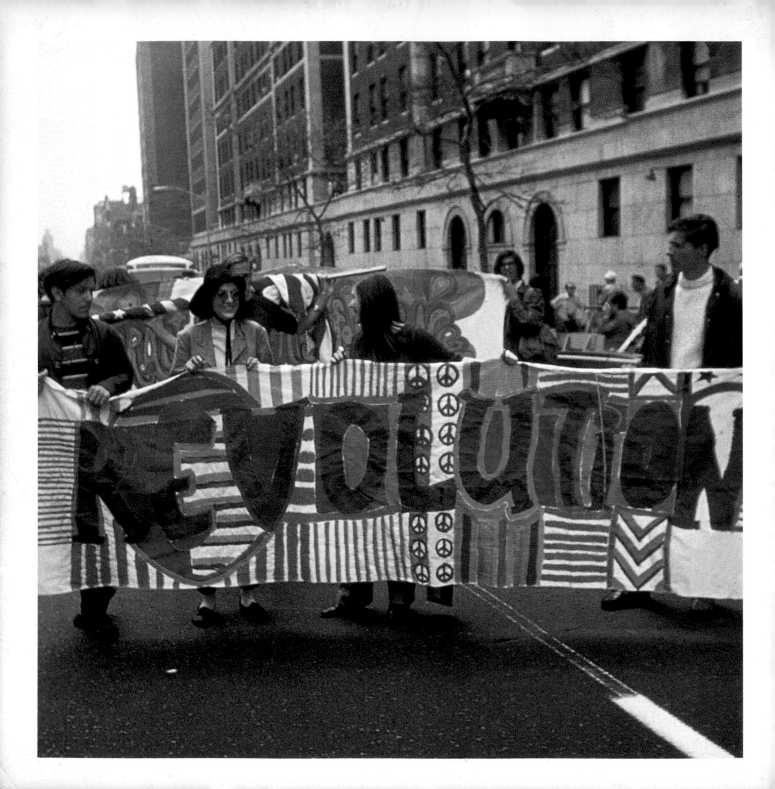

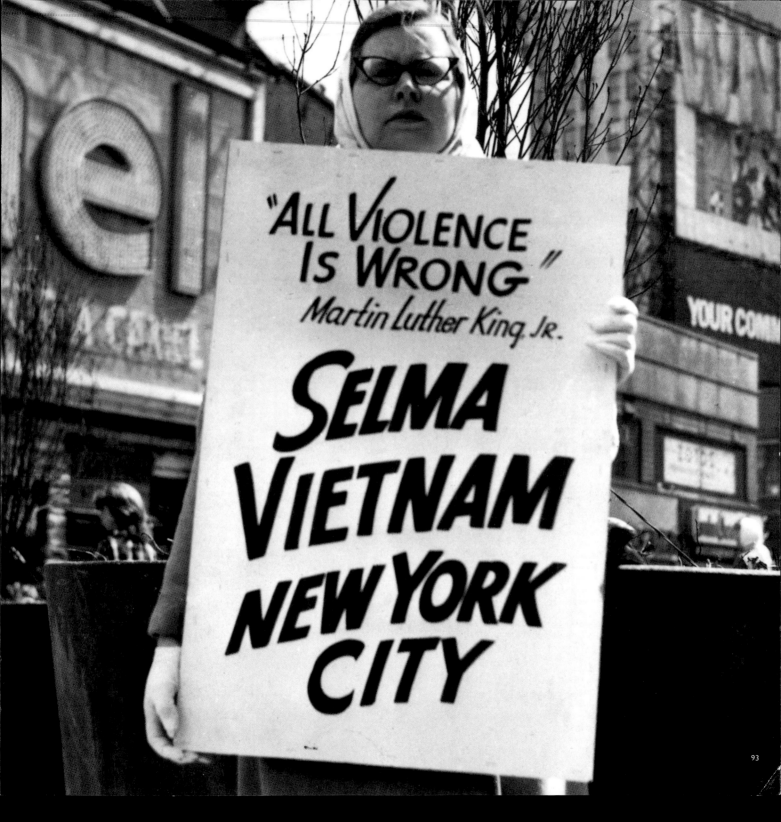

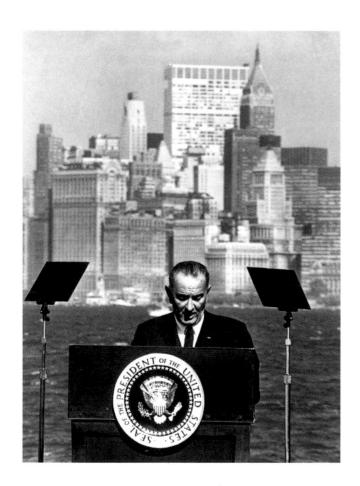

Above: **LBJ and the Big Apple**

Right: **Awaiting news of race violence**

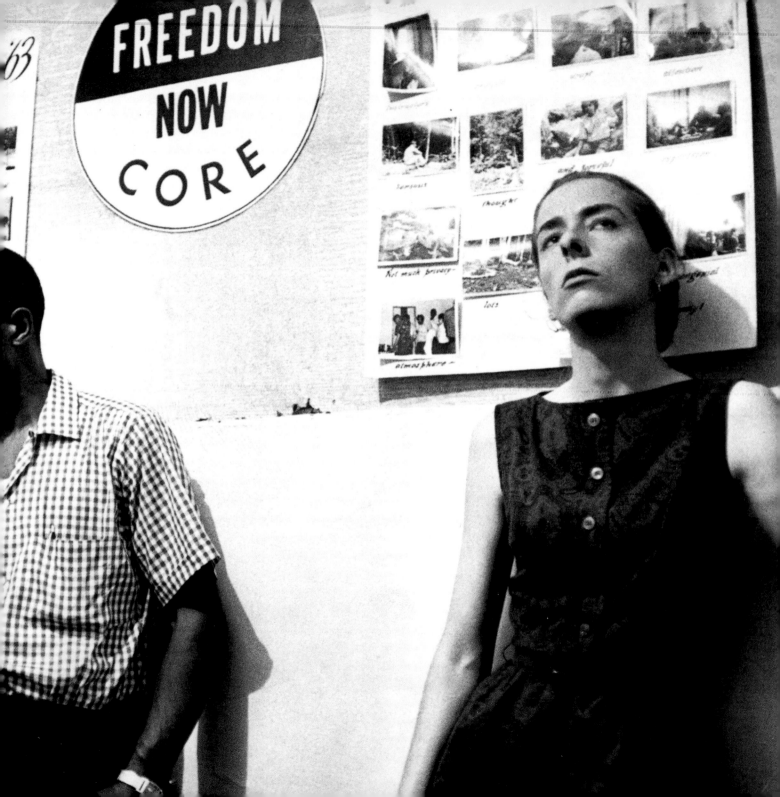

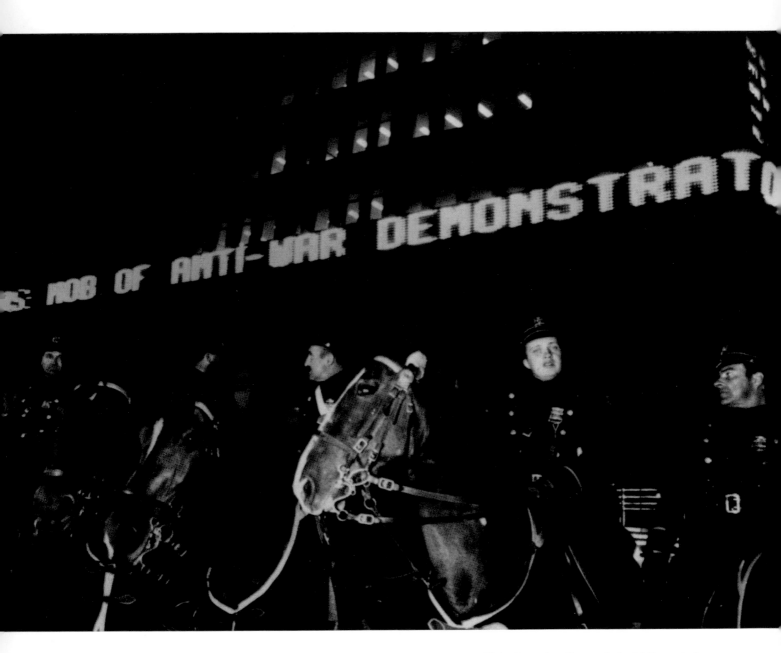

Above: Mounted police face the pacifists

Right: Bus advertisements for birth control

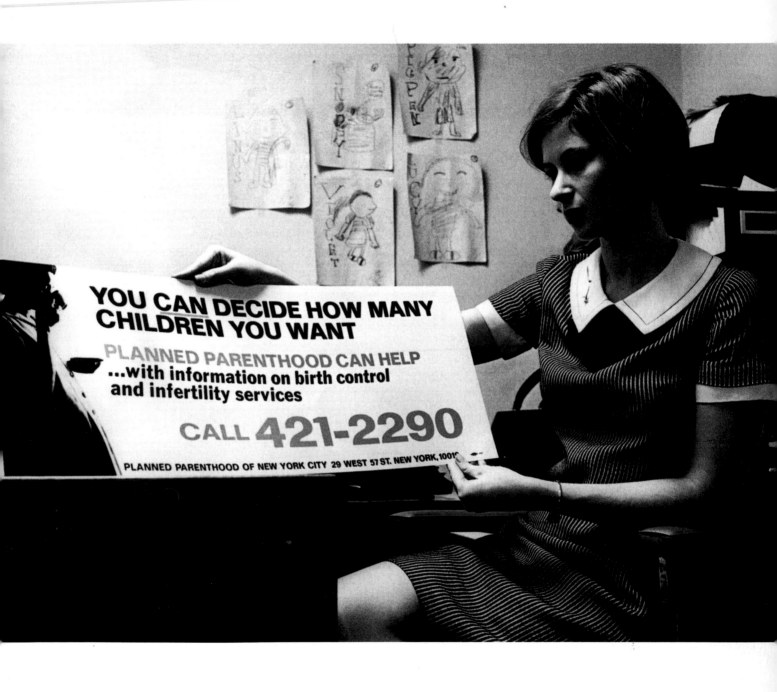

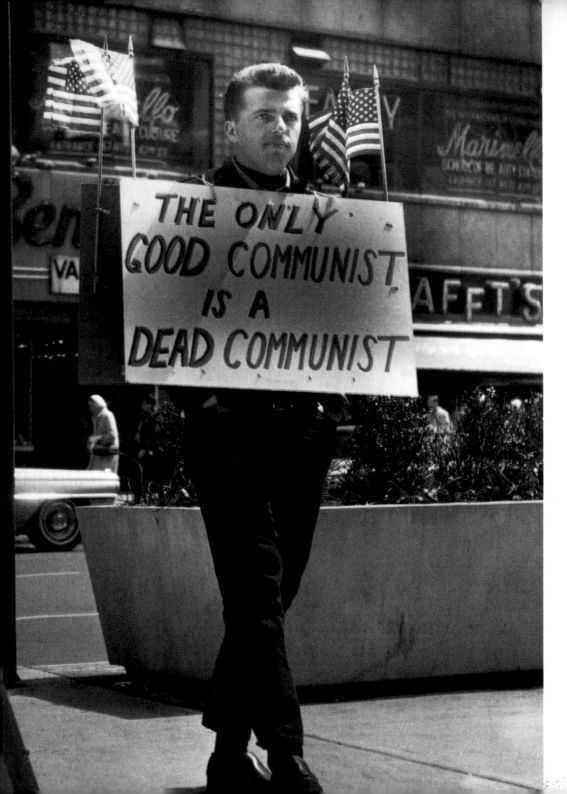

Left: One man against the Communists

Right: Fidel and Russian Premier Nikita greet each other

THE ONLY GOOD COMMUNIST IS A DEAD COMMUNIST

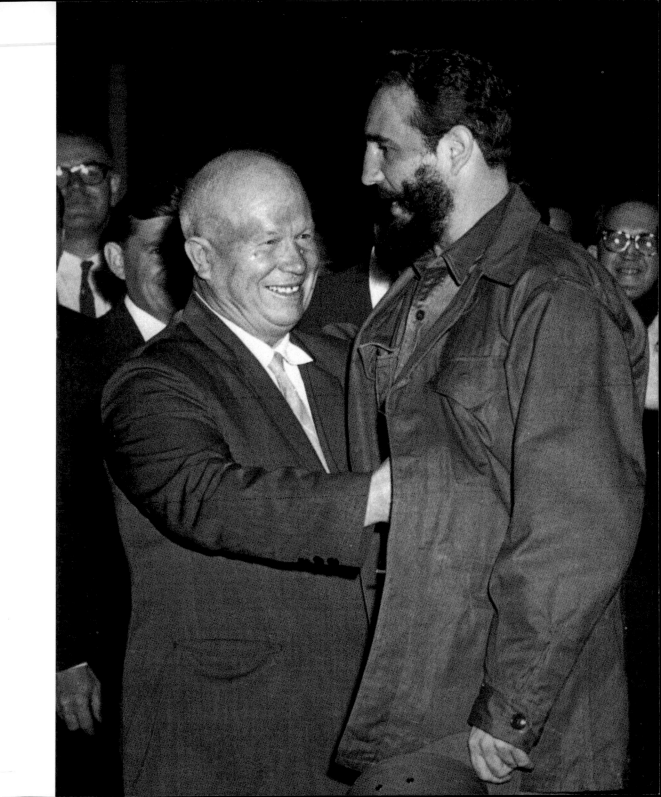

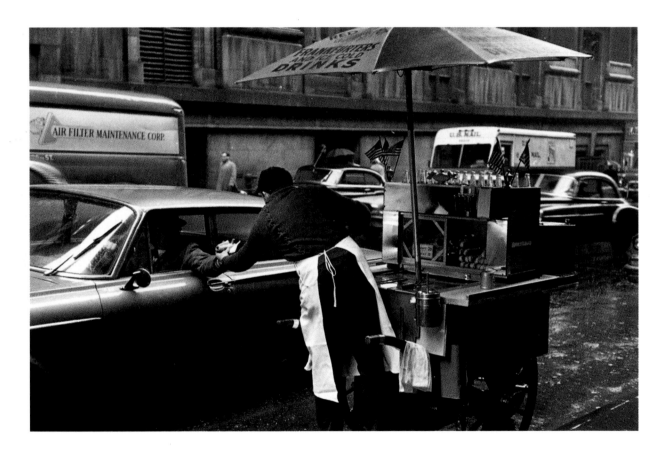

Above: Hot dog on the street

Right: Coffee in the air

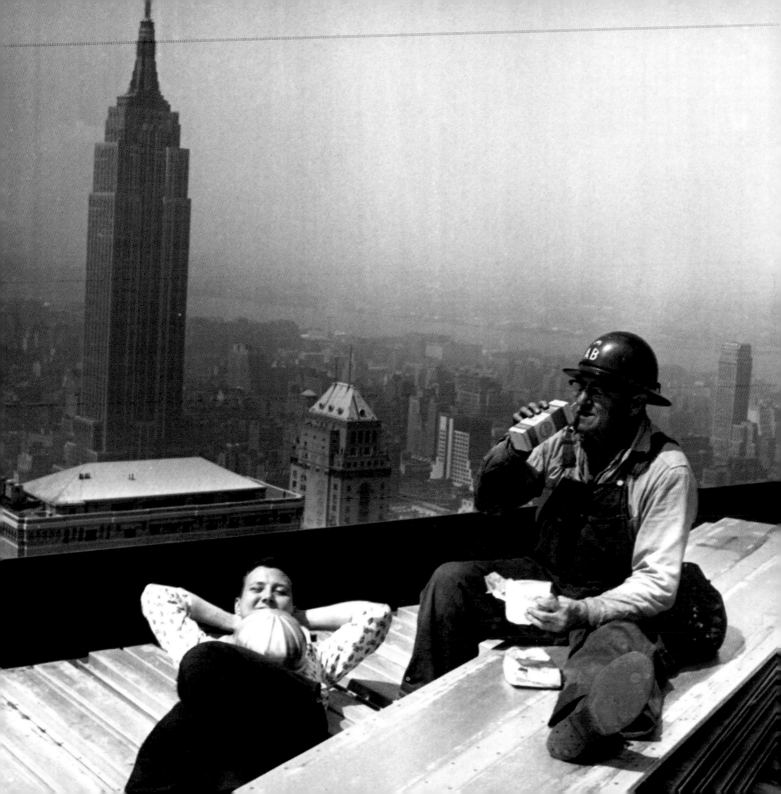

Choreographer Bob Fosse shows how

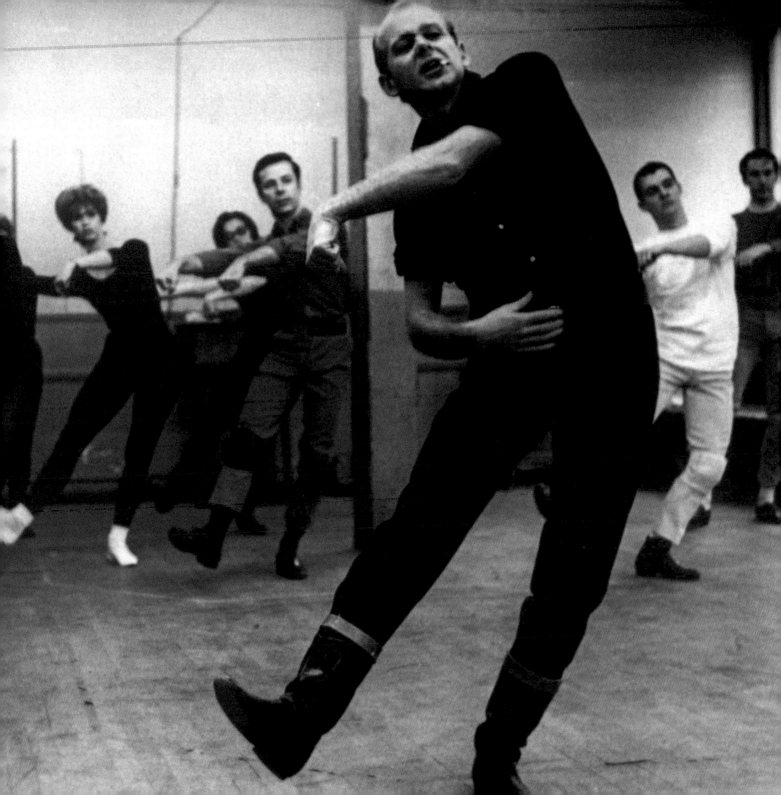

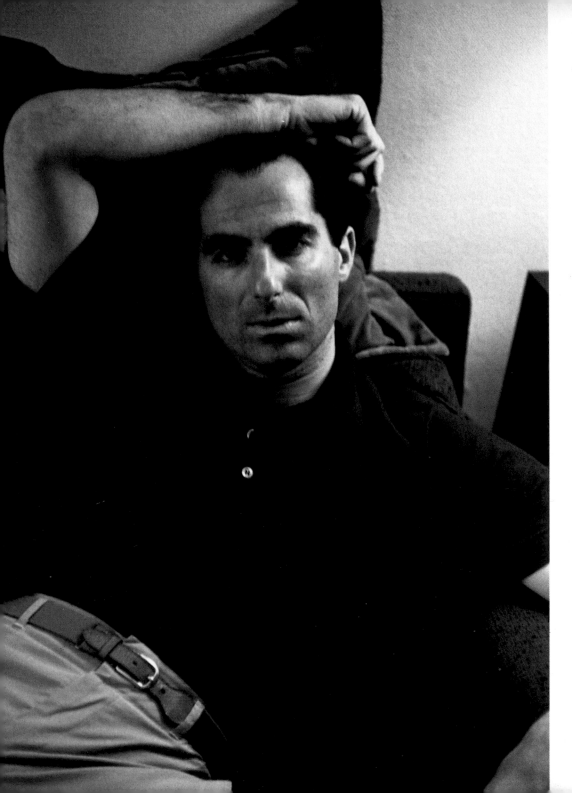

Left: Best-selling
author Philip Roth

Right: Top humorous
poet – e.e. cummings

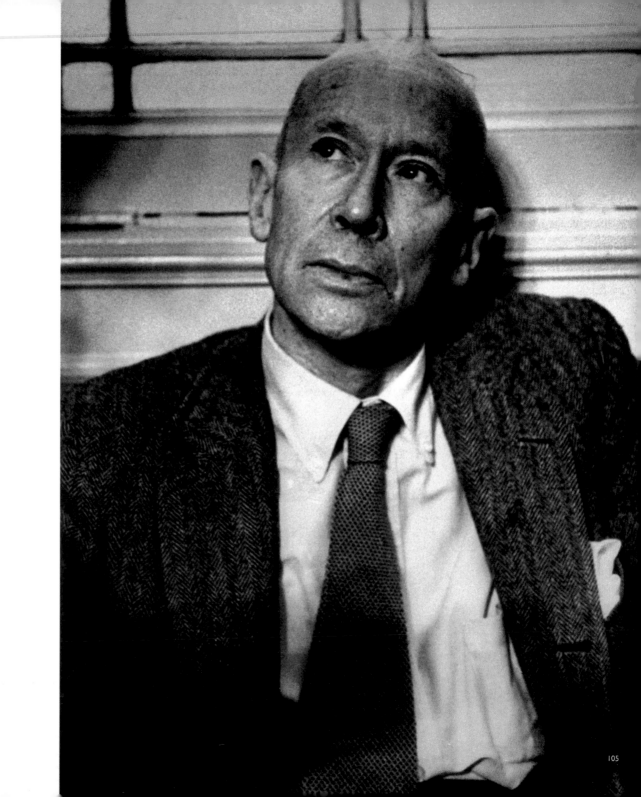

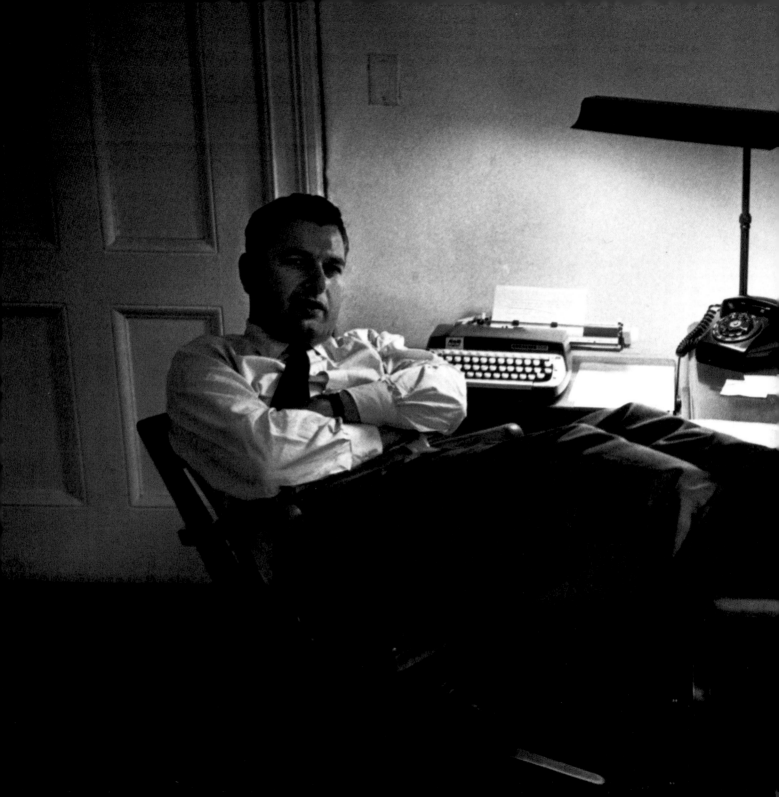

Author Joseph Heller contemplates his Catch-22

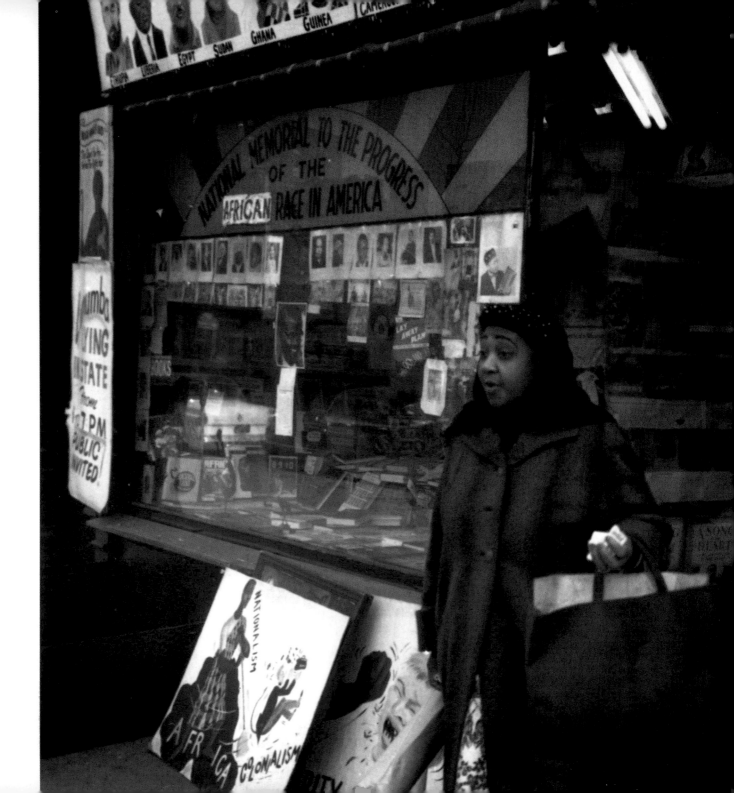

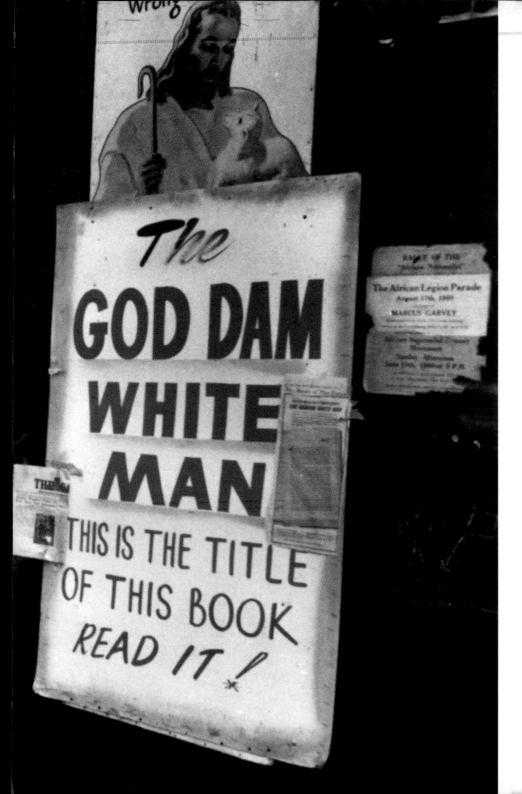

Black Muslim book store

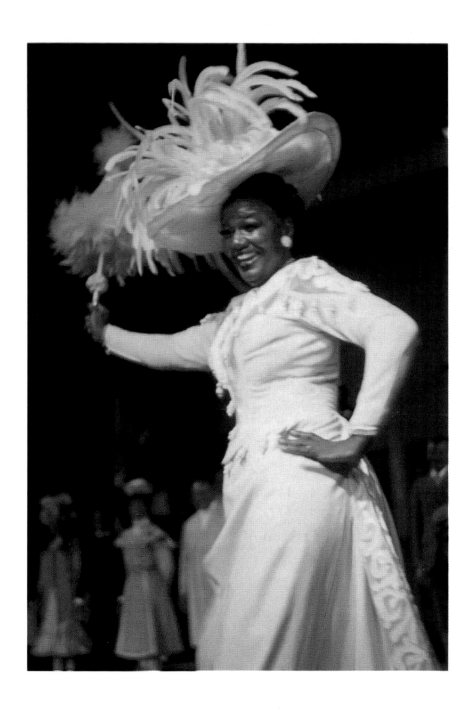

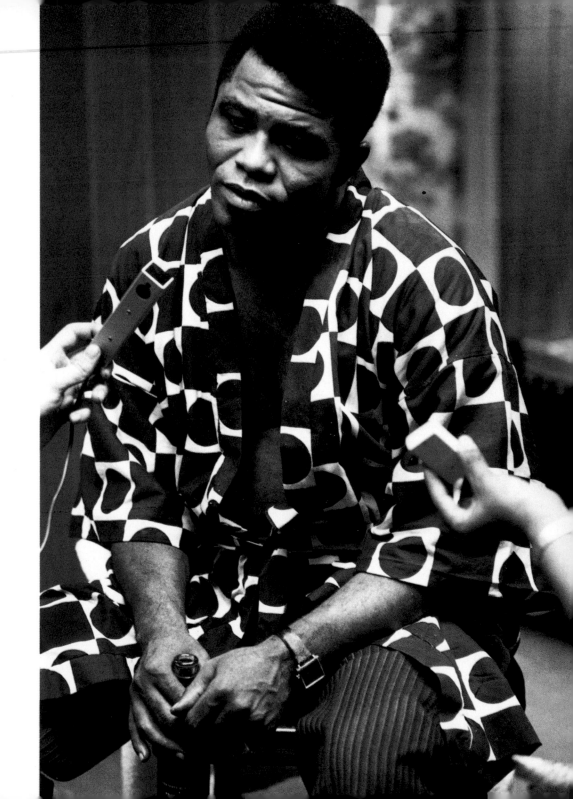

Left: Actress Pearl
Bailey plays Dolly

Right: Singer James
Brown – Black is
Beautiful

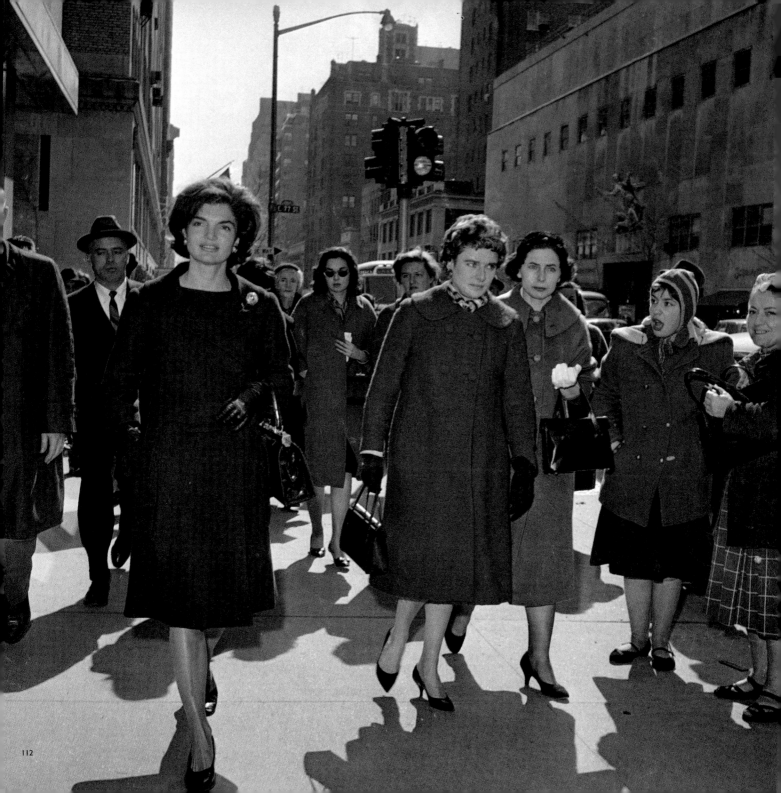

Left: Jackie on Madison Avenue

Below: The casual 'New York look'

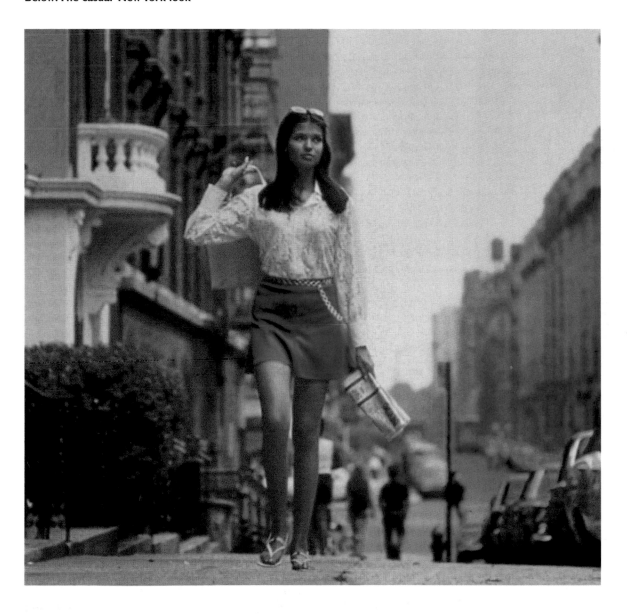

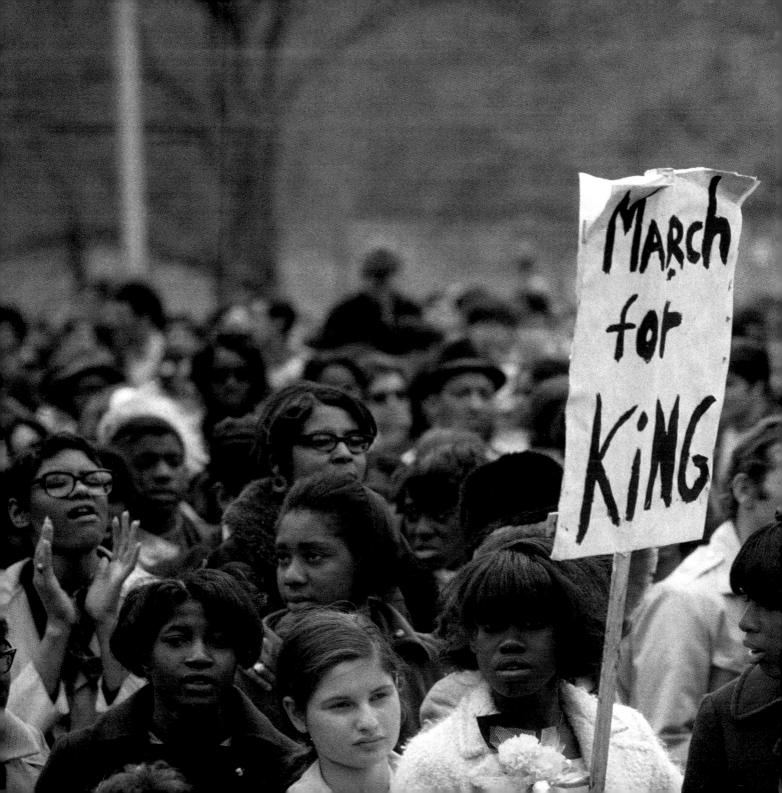

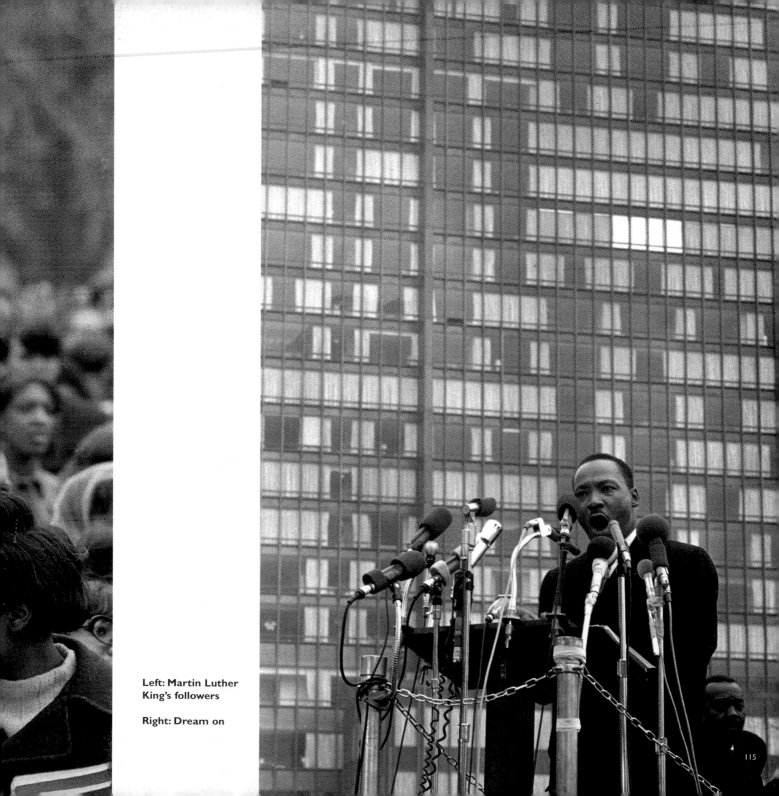

Left: Martin Luther
King's followers

Right: Dream on

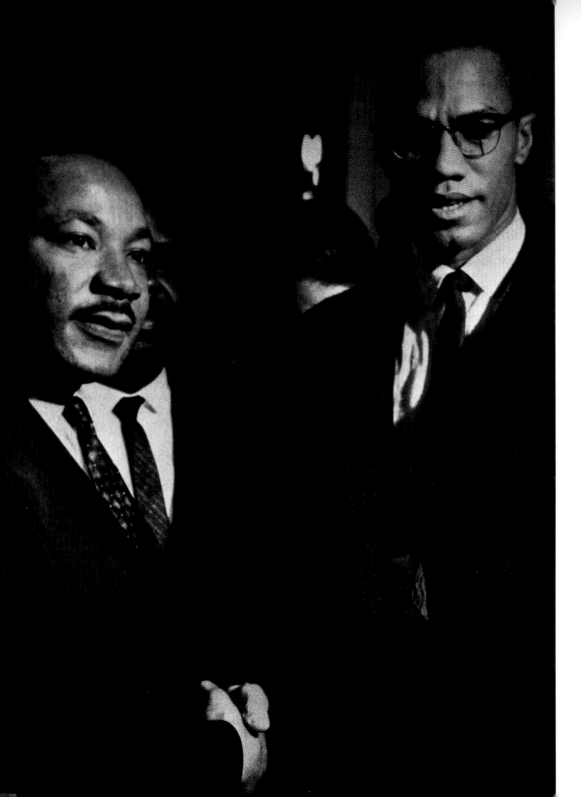

Left: Martin Luther King
and Malcolm X, both to
die by assassins

Right: Young debutantes
from Harlem

Overleaf: Up and away
– over midtown
Manhattan (left). New
spaces for the arts (right)

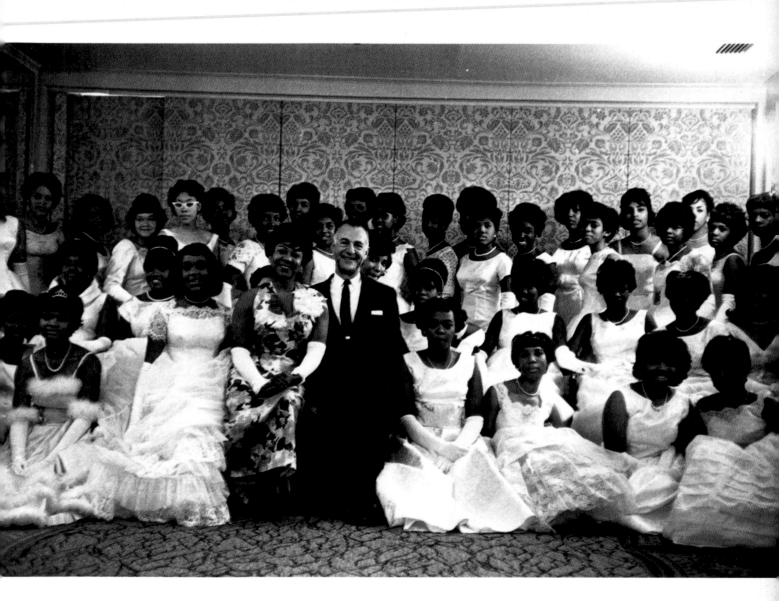

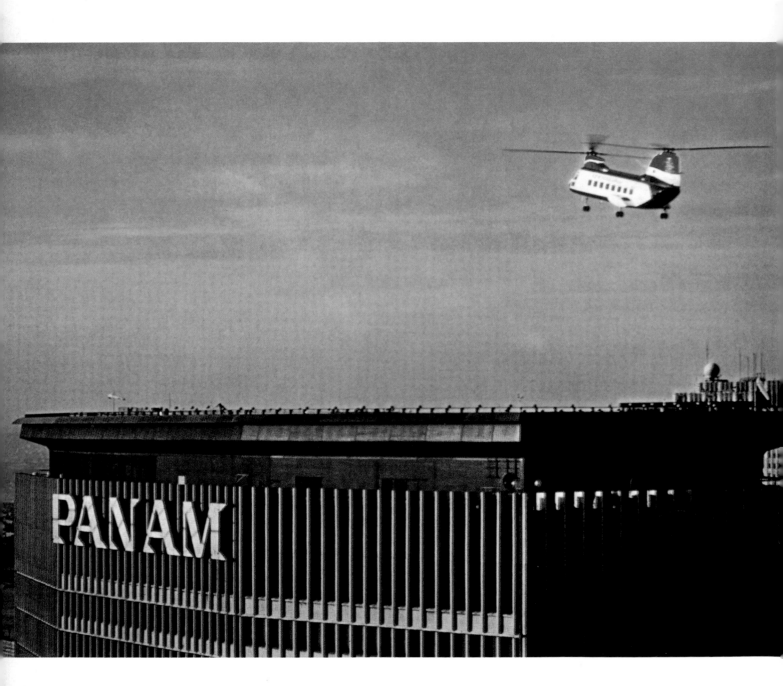

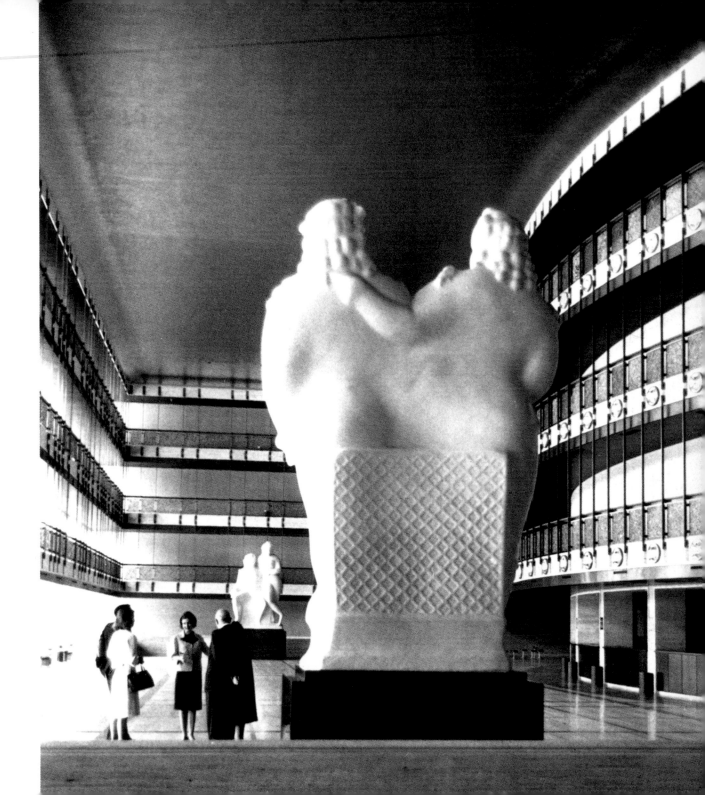

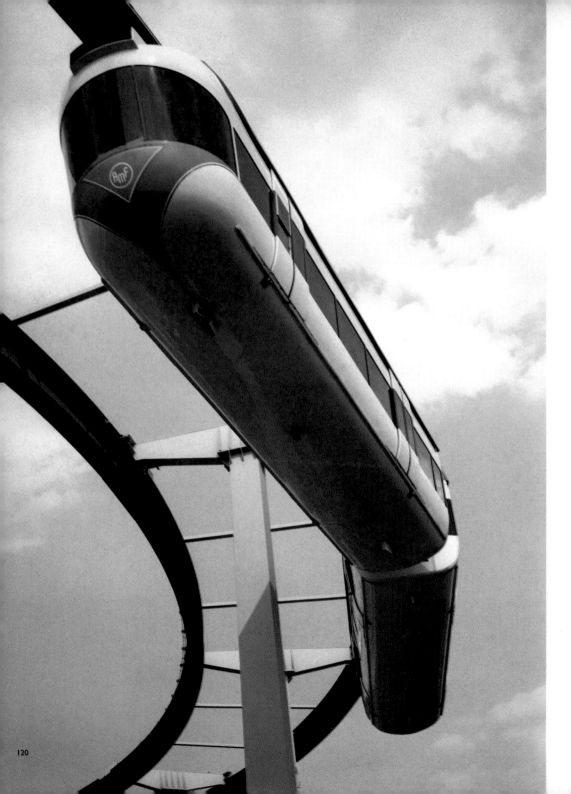

Left: Subway in reverse

Right: Crowds watch on television as Astronaut John Glenn soars into space

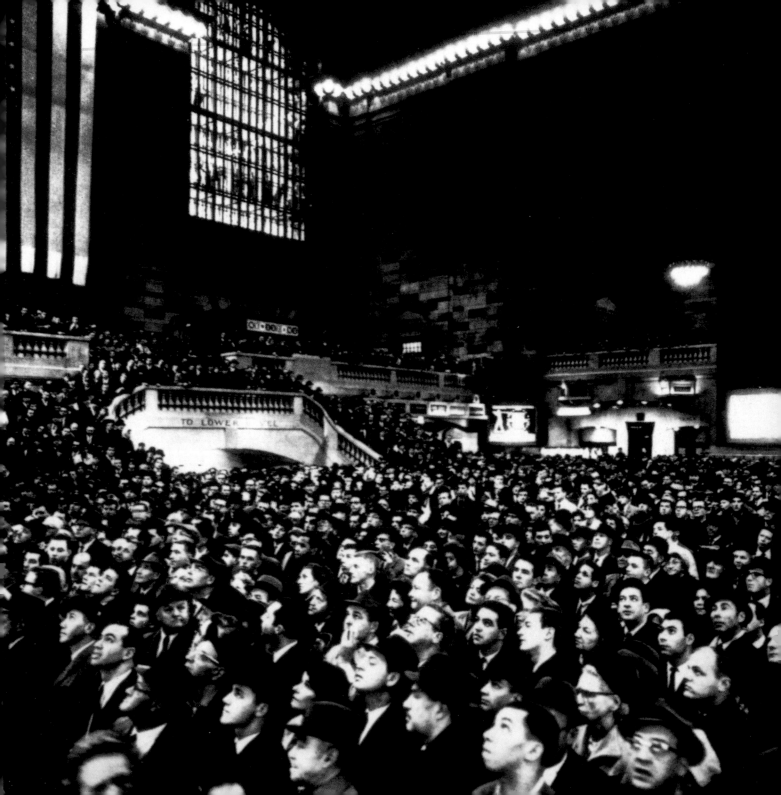

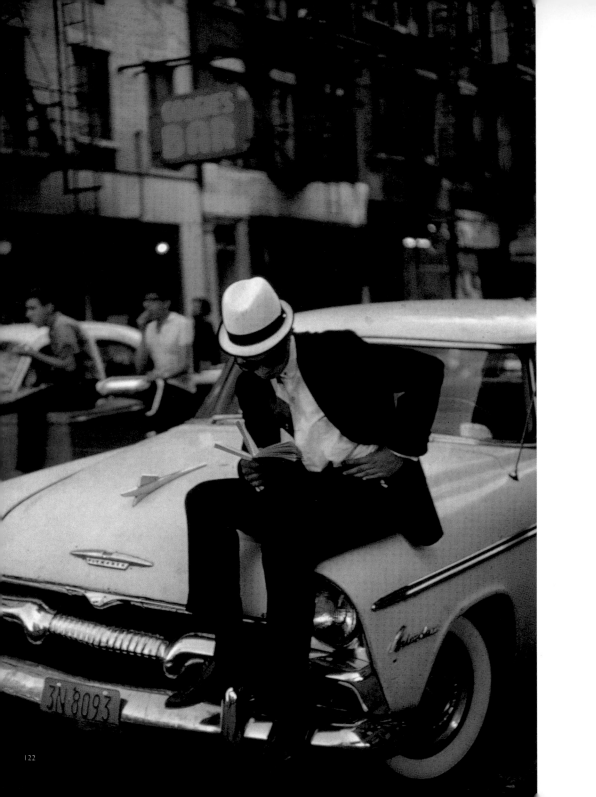

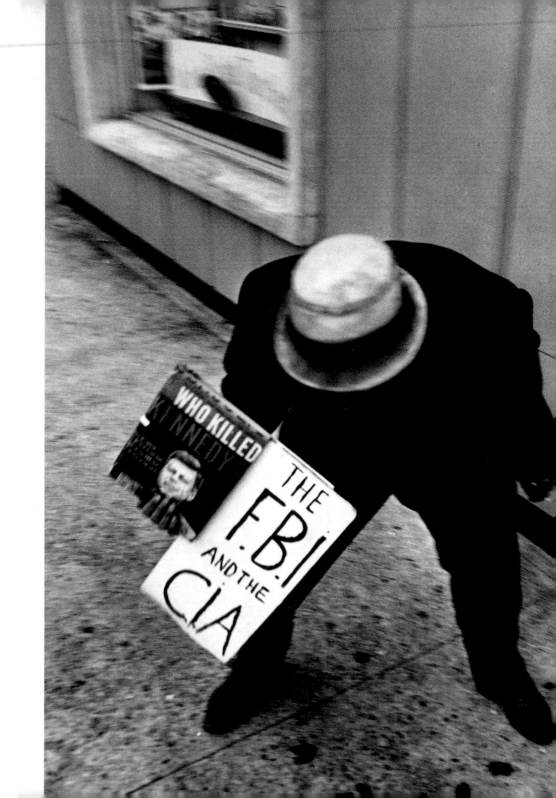

Left: Easy reading

Right: Conspiracy theorist

PHOTO CAPTIONS

Front cover: Edie Sedgwick, Andy Warhol's troubled 'superstar' dazzled New York with her wealth, glamour and beauty. Drugs destroyed her. She died in 1971.
Corbis/Bettmann/UPI

Back cover: (see page 93).
Hulton Getty

Page 5: Times Square with the statue of theatrical impresario George Cohan being studied by a fur coated, mini-skirted passer-by.
Hulton Getty

Page 10–11: Andy Warhol, the decade's *enfant terrible*, behind the camera for his film *Harlot* which he directed in 1965. Warhol, artist, wit, entrepreneur and eccentric celebrity was responsible for more than 40 films, mostly underground and made in New York, including *Empire* in which a camera was locked onto the Empire State Building for eight hours.
Eve Arnold/Magnum

Pages 12–13: Bob Dylan, the most influential folk-rock innovator of the decade, is seen here with Peter Yarrow (left) and John Hammond, Jnr. (right) hailing a cab in New York.
© Daniel Kramer

Page 14–15: Two career girls share a Manhattan apartment that is light on floor space as the rents are so high.
Constantine Manos/Magnum

Page 15: A New York neighbourhood grocery store of the 1960s, cluttered and slightly chaotic, but still holding its own against the larger chains.
Magnum

Page 16: A Harlem family belatedly enjoys its first television set. By the 1960s American TV broadcasting had entered its third decade.
Constantine Manos/Magnum

Page 17: At a Black Panther rally supporters raise their arms in the clenched-fist black power salute.
© Flip Shulke/Corbis

Pages 18–19: In 1960 Fidel Castro, president of Cuba, visited New York, to be greeted by Cuban exiles left high and dry by the revolution.
Hulton Getty

Pages 20–1: The Cuban president, Fidel Castro, holds an informal press conference on his 1960 visit to the United Nations. He startled delegates by removing his entire entourage from the hotel that the UN had booked them into, moving uptown to Harlem's Hotel Theresa where he took over 40 rooms.
Henri Cartier-Bresson/Magnum

Page 22: James Baldwin speaks out against slum landlords at a meeting called by Jesse Gray, tenants' spokesman, seated.
Camera Press

Page 23: Allen Ginsberg, poet, guru and leader of the Beat generation.
John Loengard/LIFE @ Timepix/Katz

Page 24: In the hazy background are docks,

warehouses, the East River, lower Manhattan skyscrapers and the Brooklyn Bridge, forming a picturesque backdrop for the terrace of the author Norman Mailer's apartment in Brooklyn Heights.

Inge Morath/Magnum

Page 25: Arthur Miller, eminent, controversial playwright and former husband of Marilyn Monroe, poses at the opening of his play *After the Fall*, at the Lincoln Center Repertory Theater.

Dennis Stock/Magnum

Page 26 (left): In Central Park male lovers embrace at a gay liberation gathering.

© **Leonard Freed/Magnum**

Page 26 (top): Demonstration in favour of legalizing homosexuality. The Gay Rights Movement achieved some of their objectives in the 1960s.

© **Leonard Freed/Magnum**

Page 26 (bottom): Another demonstration, this time in favour of legalizing abortion. This objective was finally achieved in the late 1960s.

Elliott Landy/Magnum

Page 27: Two participants in the Gay Rights march enjoy a quiet romantic moment.

© **Leonard Freed/Magnum**

Page 28: The Apollo on 125th Street, then a landmark of the Harlem entertainment scene, bills Billy Eckstine, Redd Foxx, Cole Atkinson and the Four Tops as its revue attractions in 1964. Now it only shows movies.

© **Bettmann/Corbis**

Page 29: Two spectators on 42nd St in the heart of the midtown entertainment district seem to be approaching a decision.

Neil Libbert/Network

Page 30: The choreographer, Jerome Robbins, on location in the Hell's Kitchen district for the film version of *West Side Story*, demonstrates to his young dancers how he wants the Sharks and Jets number to look.

© **Bettmann/Corbis**

Page 31: In 1961, the Twist was still the rage as these New York couples demonstrate. The city's safety council reported 49 cases of back injuries induced by over-vigorous dancing.

Ted Russell/LIFE @ Timepix/Katz

Pages 32–3: The astronauts Neil Armstrong, Buzz Aldrin and Michael Collins make their way along 42nd Street in triumph after their return from the Moon.

Hulton Getty

Page 33 (top): Willie Mays, the San Francisco Giants star outfielder, was honoured in a special night at the Polo Grounds in May 1963. The Giants then beat the New York Mets.

Corbis

Page 33 (bottom): The baseball immortal, the great Joe DiMaggio signs autographs at Yankee Stadium in 1960 on an 'old timers' day.

© **Bettmann/Corbis**

Page 34: Richard Avedon, doyen of fashion photography, directs a lightly clad model

during a typical photo session.
© **Burt Glinn/Magnum**

Page 35: A street vendor sells Hispanic records from Mexico and Puerto Rico on a street in Spanish Harlem.

Hulton Getty

Page 36: The isolated New York borough of Richmond (Staten Island) was joined in 1964 to Brooklyn by the construction of the double-decked Verrazano Narrows Bridge, the world's longest suspension span.

Hulton Getty

Page 37: The 1964 World's Fair was staged on the same Flushing Meadows site as its 1939 predecessor. The circular New York State Pavilion is one of a handful of structures that has survived.

© **Bettmann/Corbis**

Pages 38–9: Two elegant matrons exchange insights at a Picasso exhibition at the Museum of Modern Art.

René Burri/Magnum

Pages 40–1: Robert Kennedy and Mayor Robert Wagner shake hands in Little Italy during the former's campaign for the Senate.

© **Bettmann/Corbis**

Page 42: In 1960 John F. Kennedy and his wife Jackie campaign in New York for the upcoming Presidential election. Kennedy, a Democrat, went on to beat Richard Nixon, the Republican candidate and Eisenhower's Vice-President.

© **Bettmann/Corbis**

Pages 42–3: Vice-President Nixon opens the New York leg of his Presidential campaign, waving to the crowds on Lexington Avenue as he leaves for a vote-gathering tour of Long Island. In front of him is his wife Pat.

Hulton Getty

Page 44: Black debutantes take to the floor with their partners at a 1964 ball at the Waldorf Astoria, intending to raise funds against civil strife.

Eve Arnold/Magnum

Page 45: A shrine to John F. Kennedy beside the jukebox in a New York café.

Bruce Davidson/Magnum

Pages 46–7: A posse of artists pose with the British model Jean Shrimpton. They are (from left to right) Claes Oldenburg, Tom Wesselmann, Roy Lichtenstein, James Rosenquist and Andy Warhol.

© **Ken Heyman/ Woodfin Camp**

Page 48: Mark Sloane's Big Store on MacDougal Street in Greenwich Village stocked many thosands of lapel buttons. Among those on display in this 1967 picture are 'Impeach Earl Warren', 'Deport Mayor Lindsay' and Timothy Leary's notorious 'Turn on, tune in, drop out'.

© **Fred W. McDarrah**

Page 49: A touching event in Central Park during a 1969 anti-Vietnam protest. The black balloons signify the dead and the white ones those who are going to die.

Mark H Merson/Black Star/Colorific!

Pages 50 and 51: Leonard Bernstein, conductor and musical director of the New York Philharmonic, and doyen of the music world, wields his baton.
© Ken Heyman/Woodfin Camp

Page 52: The banner on St Mark's Place hangs in front of The Dom, the old Polish National Social Hall, where in 1968 Andy Warhol's 'Exploding Plastic Inevitable', a multimedia light show extravaganza with the Velvet Underground, was staged.
© Fred W. McDarrah

Page 53: The lights of Broadway theatres on West 44th Street, temporarily dimmed in an eight-day actors' strike in 1960, are turned on again after a settlement. At the Majestic theatre, a musical about the legendary former mayor of New York, Fiorello La Guardia, is being staged.
UPI/Corbis

Page 53 (far right): Elliott Gould, then husband of the young Barbra Streisand, kisses her affectionately. Streisand, with her beehive coiffure and Nefertiti nose, was a stagestruck kid from Brooklyn who became the toast of Broadway during the lengthy run of *Funny Girl*, a musical based on the life of the Jewish comedienne Fanny Brice.
© Bettman/Corbis

Page 54: A poster heralds a week-long convention of beatniks in 1960 to choose a presidential candidate. The convention was held at a coffee house on West 10th Street known as the College of Complexes. Slim

Brundage, leader of a beat group, wags a thumb at it.
Corbis

Page 55: The Gaslight Poetry Café on MacDougal Street in Greenwich Village was a popular hangout for the literati.
Corbis – Bettmann

Pages 56–7: Dennis Hopper, star and director of *Easy Rider*, and the co-writer Terry Southern, who also co-wrote the screenplay for *Dr Strangelove*, in front of the Chelsea Hotel.
© Fred W. McDarrah

Page 57: Timothy Leary, advocate of the free use of LSD and other prohibited substances, holds a New York press conference for peace with Abbie Hoffman and Jerry Rubin on the brink of the Democratic Party's 1968 convention in Chicago. The banner behind has superimposed an image of Lyndon B. Johnson, outgoing president on a photograph of Hitler.
AP

Page 58: A Warhol gathering at the Factory in 1965, with Edie Sedgwick on the left and Billy Name on the right. Behind is a hanging of Andy Warhol's cow wallpaper.
© Fred W. McDarrah

Page 59: The cast of *Ciao Manhattan*, an underground film that reached the surface, pose at a New York health club used as a location. Seated third from right is its ill-fated star Edie Sedgwick, the screenwriter Genevive Charbin holds the clapperboard, and standing

behind is director Chuck Wein.
Corbis – Bettmann/UPI

Pages 60–1: Jimi Hendrix plays at Woodstock, the culminating rock festival of the 1960s, held in a field in the Hudson Valley, a two-hour drive north of New York City.
© Dan McCoy/Black Star/Colorific!

Page 61: A folk-rock group entertain a crowd in Washington Square, the forum of Greenwich Village.
© Fred W. McDarrah

Pages 62–3: The unchanging New York passing crowd. At this busy junction of Broadway, 6th Avenue and 34th Street shoppers and office workers mingle.
UPI/Corbis

Page 63 (top): *Muhammed Speaks*, the Black Muslim paper, is hawked on the streets of Harlem.
Hulton Getty

Page 63 (bottom): Concerned blacks try to attract support.
Camera Press

Page 64: Horn player, Miles Davis, performs in 1967.
© Redferns

Page 65 (top): Charles Mingus takes the stand at the Five Spot Café, 1962. And Thelonius Monk performs in a recording session at Atlantic Blue (bottom).
© Fred W. McDarrah

Page 66: A stylish motor bike is given sidewalk attention by its young owner.
© Charles Harbutt/Actuality Inc.

Page 67: Flowery Easter bonnets bedeck two of the participants in the 1968 'yip-out' in the Sheep Meadow, Central Park, a peaceful gathering for the Youth International Party.
Corbis/Bettmann

Page 68: Dresses inspired by pop artists, including Andy Warhol, who elevated the Brillo box to a design icon.
© Ken Heyman/Woodfin Camp

Page 69: The inspirational and innovative artist Willem de Kooning shares a smoking break with Ruth Kligman in this 1962 photograph taken at his studio on Broadway.
© Dan Budnik/Woodfin Camp

Page 70: The artist Isamu Noguchi poses by one of his striking sculptures.
© Dan Budnik/Woodfin Camp

Page 71: Artist Jasper Johns appears to be less assertive than his painting.
© Dan Budnik/Woodfin Camp

Page 72: A prolonged newspaper strike in the mid-1960s winnowed the New York newspaper world to a shadow of what it had been. Here are many of the defunct titles including the *World-Telegram* and the *Journal-American*.
© Fred W. McDarrah

Pages 72–3: The comedian Lenny Bruce pioneered a special brand of humour that was both funny and serious, a tragi-comedy act in which his heavy drug usage was a key element. He died from

complications of an operation in 1966.

© Fred W. McDarrah

Page 74: The charismatic New York mayor John Lindsay, voted into office in 1965, munches in public.

Charles Moore/Black Star/Colorific!

Page 75: Major John Lindsay was the same age as President Kennedy when he was elected and, although a Republican, he exerted a similar attraction, particularly on women voters. During his term of office he devolved many central municipal powers to local community watchdog groups.

Colorific!

Page 76: On Fifth Avenue passers by, capturing the feelings of grief that encompassed the nation, weep involuntarily at the news of President Kennedy's assassination in Dallas in November 1963.

© Charles Harbutt/Actuality Inc.

Page 77: A two-ton eagle is removed from the roof of Pennsylvania Station in October 1963, the start of the demolition of the great building, designed by McKim, Mead and White. The destruction of Penn Station shocked New Yorkers into an appreciation of their architectural heritage, and some proposed atrocities were aborted.

UPI/Corbis

Page 78: At the Brooklyn Academy of Music in May 1968 the dancer Merce Cunningham points a toe in *How to Pass, Kick, Fall and Run*, with David Vaughn,

seated and the composer John Cage on the left.

© Fred W. McDarrah

Page 79: George Balanchine, dancer and choreographer, rehearses members of the New York City Ballet in 1965.

Hulton Getty

Page 80: On 27th June, 1969 the Stonewall Inn, a favourite watering place for homosexuals, was raided by the police. Instead of meekly surrendering, the gays, about 200 in number, fought back. Further riots occurred on the two succeeding nights. Stonewall became a battle honour in the Gay Pride struggle and a landmark in the campaign to change the law.

© Fred W. McDarrah

Page 81: The Electric Circus, a new venue for the junior set opens in Greenwich Village with a benefit for the Children's Recreation Foundation. Partygoers' fashions are eclectic, ranging from tuxedos to elastic-sided boots.

UPI/Corbis

Page 82: Betty Friedan published her best-selling book, *The Feminine Mystique* in 1963. The book covered many women's issues, including their frustrations with marriage and children, and it set up a chain reaction with lasting effects. It established her as the leading advocate of women's rights.

© Steve Schapiro/Black Star/Colorific!

Page 83: Timothy Leary on stage at Fillmore East, Bill Graham's New York echo of his

rock venues in San Francisco.

© Charles Harbutt/Actuality Inc.

Page 84: Peace demonstration in Bryant Park.

Elliot Landy/Magnum

Page 85: A British model walks down Fifth Avenue in 1966 in a 'swinging London' miniskirt, attracting curious glances from other pedestrians. Later the American fashion market embraced the mini as avidly as trendsetters across the Atlantic.

Corbis/Bettmann/UPI

Page 86: Cuban flags are waved in a demonstration against the Vietnam war. The pig mask is a reference to 'Pigasus', the Yippie presidential nominee.

© Charles Harbutt/Actuality Inc.

Page 87: In 1962, before the liberalization of laws against homosexuality, police harassed and arrested guests at National Variety Artists Exotic Carnival and Ball at the Manhattan Center on supposed grounds of public indecency. This transvestite is escorted to the police van.

Corbis

Page 88: In April 1967, anti-Vietnam war protestor marched to the United Nations building draped in the stars and stripes, hung upside down – the traditional distress signal.

© Fred W. McDarrah

Page 89: The acerbic novelist and socialite Truman Capote dances with Princess Lee Radziwill, Jackie Kennedy's sister, at his celebrated Black and

White Ball in November 1960.

Hulton Getty

Page 90: Youths gather around a Harlem fast food outlet.

James Mitchell/Magnum

Page 91: The Astor ballroom is crammed with dancers for the International Debutante Ball in 1964. The old hotel was later demolished and substituted with an office building.

© Bettmann/Corbis

Page 92: A colourful banner is unfurled in a good-humoured but traffic-halting protest in the wealthy neighbourhood of Central Park West.

© Steve Shapiro/Black Star/Colorific!

Page 93: A woman member of the Society of Friends takes a stand in Times Square to protest against the Vietnam War, invoking a dictum of Martin Luther King. Behind her can be seen a portion of the famous sign for Camel cigarettes that actually puffed smoke across the square until the mid-1960s.

Hulton Getty

Page 94: President Lyndon B. Johnson speaks against the world-famous backdrop of Lower Manhattan.

Hulton Getty

Page 95: At the Harlem headquarters of the Campaign for Racial Equality (CORE) members await news of fresh violence.

David Steen/Camera Press

Page 96: Mounted police stand fast during a pacifist

demonstration in Times Square.
Elliott Landy/Magnum

Page 97: A decision was made to advertise birth control on New York buses. The publicity director of Planned Parenthood displays an advertisement.
Hulton Getty

Page 98: A one-man protest against communism, a New York bartender displays his banal message to anyone in Times Square who looks his way.
Hulton Getty

Page 99: The Russian premier Nikita Khruschev greets President Fidel Castro of Cuba before a dinner at the Soviet legislation on their joint visit to New York in September 1960.
© Bettmann/Corbis

Page 100: A hot dog vendor serves a passing motorist on a wet day in 1962.
David Hurn/Magnum

Page 101: Construction workers take a coffee break on the 59th floor of the uncompleted Pan Am building, with the Empire State Building looming ten blocks away in the background.
Hulton Getty

Pages 102–3: Bob Fosse, whose energetic, angular dance style redefined Broadway choreography, leads his dancers in rehearsal for *Pleasures and Palaces* that he directed in 1965. Characteristically he puffs a cigarette. He was to eventually

die from lung cancer.
© Bettmann/Corbis

Page 104: Author Philip Roth, enjoyed considerable acclaim with *Portnoy's Complaint*, which humorously explored the sexual condition, earning it the nickname 'the gropes of Roth'.
Eve Arnold/Magnum

Page 105: Wit, humorous versifier, painter and eccentric punctuator, e.e. cummings died, much mourned, in 1962, aged 67. Although his name was usually styled without upper case letters, when he signed cheques he used initial capitals like everybody else.
© Bettman/Corbis

Pages 106–7: Joseph Heller, seen here in his 57th Street office in 1965, enjoyed a phenomenal success with his satirical war novel *Catch-22* published in 1961. He spent the rest of his life trying to better it, a futile task as it happened.
© Inge Morath/Magnum

Page 108–9: In Harlem a book store is the focus for gatherings of Black Muslims in 1961.
Henri Cartier-Bresson/Magnum

Page 110: Pearl Bailey, one of a long line of stars who played the title role in the hit Broadway musical *Hello, Dolly!* and the first non-white in the part.
John Dominis/LIFE @ Timepix/Katz

Page 111: The singer James Brown is questioned by the

media after a concert in which the phrase: 'Black is beautiful' was uttered in public for the first time.
Eve Arnold/Magnum

Page 112: The First Lady, Jackie Kennedy, surprises other shoppers on Madison Avenue as she makes the most of a three-day New York visit in 1961.
© Bettmann/Corbis

Page 113: By 1969 the New York look, long hair, long legs and a casual deportment was the hallmark of the young career woman.
Vernon Merritt/LIFE @Timepix/Katz

Page 114: A demonstration in Central Park on behalf of Martin Luther King.
Bruce Davidson/Magnum

Page 115: The eloquent Baptist minister, Martin Luther King, who became the figurehead of the civil rights movement was assassinated in 1968.
Burt Glinn/Magnum

Page 116: Martin Luther King shakes hands with Malcolm X, the black nationalist leader, in 1964. Both men were to die from assassin's bullets.
© Bettman/Corbis

Page 117: Debutantes from Harlem posing with a city Commissioner.
Eve Arnold/Magnum

Page 118: Direct helicopter links from 44th Street in

midtown Manhattan to the New York airports became possible from the helipad on top of the controversial 1963 Pan Am building above Grand Central Terminal. A fatal crash ended the service abruptly.
© Bettman/Corbis

Page 119: The lobby of the New York State Theater at the Lincoln Center of 1964. The architect was Philip Johnson who designed it with the sculptures in mind.
Erich Auerbach/Hulton Getty

Page 120: One of the attractions at the New York World's Fair was a suspended monorail train, but unlike a similar venture in Seattle, it was later dismantled.
© Bettman/Corbis

Page 121: A huge crowd watched on a giant screen, installed for the occasion in the concourse of Grand Central by the CBS television network, as the astronaut, John Glenn, ascended into space in 1962.
AP

Page 122: In the summer of 1962 a man quietly sits reading on the front of a car parked on a New York street.
Ernst Haas/Hulton Getty

Page 123: After John Kennedy's assassination, speculation and suspicion took root. This man, outside the Lincoln Center, blames the FBI and the CIA.
René Burri/Magnum

Reeve, Simon.

The new jackals.

DATE			